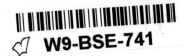
LOUD BONES

Northwest Perspective Series

TACOMA **ART** MUSEUM

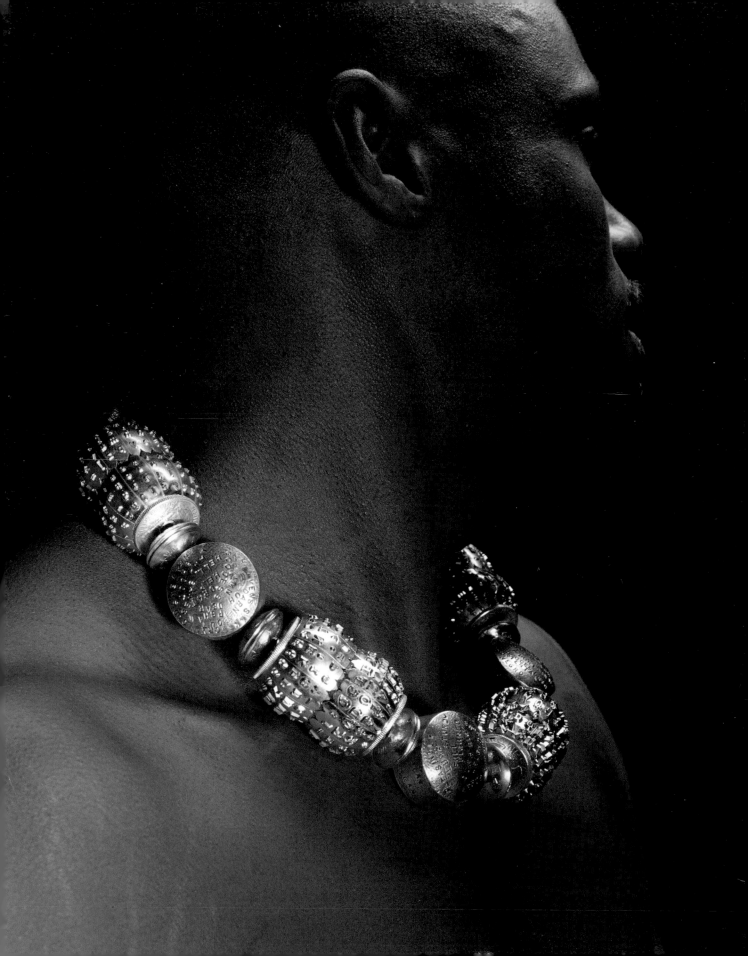

LOUD BONES
THE JEWELRY OF NANCY WORDEN

Michelle LeBaron

Susan Noyes Platt

With contributions by Rock Hushka and Nancy Worden

Foreword by Helen Williams Drutt English

TACOMA ART MUSEUM
TACOMA, WASHINGTON

Published in conjunction with the exhibition *Loud Bones: The Jewelry of Nancy Worden*, which appears at Tacoma Art Museum June 27 through September 20, 2009 and at the Hallie Ford Museum of Art, Willamette University, November 21, 2009 through January 17, 2010.

Funding for *Loud Bones: The Jewelry of Nancy Worden* generously provided by the ArtsFund/Guendolen Carkeek Plestcheeff Decorative and Design Arts Fund, Susan Beech, and Dale A. Meyer and Janeanne A. Upp.

Publisher:
Tacoma Art Museum
1701 Pacific Avenue
Tacoma, Washington 98402
www.TacomaArtMuseum.org

Distributor:
University of Washington Press
P.O. Box 50096
Seattle, WA 98145-5096
www.washington.edu.uwpress

Designed by Phil Kovacevich; edited by Rebecca Jaynes; proofread by Zoe Donnell;
printed and bound in Canada by Friesen's, Inc.

ISBN: 978-0-924335-28-0 (cloth); 978-0-924335-29-7 (pbk.)

Library of Congress Cataloging-in-Publication Data
LeBaron, Michelle, 1956-
 Loud bones : the jewelry of Nancy Worden / Michelle LeBaron, Susan Noyes Platt ; with contributions by Rock Hushka and Nancy Worden ; foreword by Helen Williams English Drutt.
 p. cm. — (Northwest perspective series)
 Published in conjunction with an exhibition held at the Tacoma Art Museum, June 27-Sept. 20, 2009 and at the Hallie Ford Museum of Art, Willamette University, Nov. 21, 2009-Jan. 17, 2010.
 ISBN 978 0 924335-28-0 (hardcover) — ISBN 978-0-924335-29-7 (pbk.) 1. Worden, Nancy, 1954—-Exhibitions. I. Worden, Nancy, 1954- II. Platt, Susan Noyes, 1945- III. Hushka, Rock, 1966- IV. Tacoma Art Museum. V. Hallie Ford Museum of Art. VI. Title. VII. Title: Jewelry of Nancy Worden.
 NK7398.W67A4 2009
 739.27092—dc22

 2009005593

Copyright Permissions
All reproductions of artwork by Nancy Worden appear courtesy of the artist. All reproductions of other artwork appear courtesy of the following: figure 7, Estate of Ken Cory; figure 8, Estate of Donald Tompkins, figure 10, Estate of Olaf Skoogfors; figure 11, Gary Noffke; figure 17, Leslie LePere.

Photographic Credits
Cover; figures 1–2, 5, 8–9, 13, 21–29, 31, 36–37, 41–43; plates 17, 19–40, 42–48; pages 9, 64, 110, 123 (in the studio), 128: photos by Rex Rystedt; provided by Nancy Worden
Frontispiece; figures 6–7, 15–20, 33–34, 38–39, 44–45; plates 5, 7–10, 12–16, 18; pages 120 (locket), 121 (GAP Grant and *Charity Tiara*): photos by Lynn Hamrick Thompson; provided by Nancy Worden
Figures 3, 12, plates 1, 3–4, 6, 30, 41; page 120 (brooch): photos by Doug Yaple; provided by Nancy Worden
Figure 4: photo by Craig Smith; provided by the Heard Museum, Phoenix, AZ.
Figure 10: photo provided by Museum of Fine Arts, Houston
Figure 11: photo by Gary Noffke; provided by Gary Noffke
Figure 14: photo © 1987 The Detroit Institute of Arts; provided by Detroit Institute of Arts
Figure 32, page 120 (cup): photos by Nancy Worden; provided by Nancy Worden
Figure 35: photo by Paul Macapia; provided by Seattle Art Museum
Plate 2; page 121 (age 40): photos by Joel Levin; provided by Nancy Worden
Plate 11; page 122 (*Ornament* cover): photos by Robert Liu; provided by Nancy Worden
Page 13: photo by Doug Tucker; provided by Nancy Worden

Cover: *Ereshkigal's Hook*, 2004 (full caption page 98). Frontispiece: *Terminology*, 1996 (full caption page 77).
Page 64: *Exosquelette #2* (detail), 2003 (full caption page 94).

CONTENTS

7 DIRECTOR'S FOREWORD AND ACKNOWLEDGEMENTS
STEPHANIE A. STEBICH
TACOMA ART MUSEUM

11 DIAL "N" FOR NANCY
FOREWORD BY HELEN WILLIAMS DRUTT ENGLISH
JEWELRY COLLECTOR, GALLERIST, AND SCHOLAR

15 ADORNMENT, ARMOR, AND AMULETS:
THE ASTONISHING JEWELRY OF NANCY WORDEN
SUSAN NOYES PLATT, PH.D.
ART HISTORIAN AND CRITIC

43 LOUD BONES: NANCY WORDEN'S JEWELRY
MICHELLE LeBARON
PROFESSOR OF LAW AND DIRECTOR,
UNIVERSITY OF BRITISH COLUMBIA PROGRAM ON DISPUTE RESOLUTION

65 WORKS IN THE EXHIBITION

111 INTERVIEW WITH NANCY WORDEN
ROCK HUSHKA
CURATOR OF CONTEMPORARY AND NORTHWEST ART,
TACOMA ART MUSEUM

116 EXHIBITION CHECKLIST

119 CHRONOLOGY AND INFLUENCES
COMPILED BY ROCK HUSHKA AND NANCY WORDEN

124 ARTIST AND CURATOR ACKNOWLEDGEMENTS

126 TACOMA ART MUSEUM BOARD OF TRUSTEES AND STAFF

128 LENDERS TO THE EXHIBITION

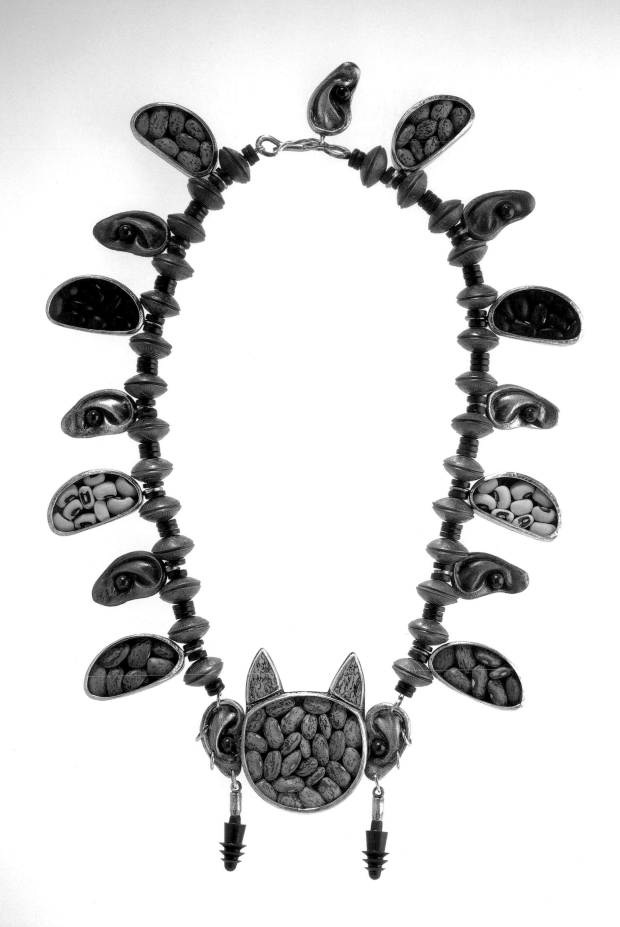

DIRECTOR'S FOREWORD AND ACKNOWLEDGEMENTS

Stephanie A. Stebich

POWERFUL, BEAUTIFUL, HUMOROUS, BOLD. These are some of the words that describe Nancy Worden's work. She is an artist of international stature, yet her work continues to evolve as she challenges both herself and viewers of her work. From her delicate and intricately wrought brooches made with eyeglass lenses to her formidable neckpieces reminiscent of armor, Nancy Worden creates richly symbolic objects that reference tradition while actively engaging with the modern world.

Nancy Worden has had a long association with Tacoma Art Museum, beginning in 1988 with her inclusion in the *Northwest Crafts* show, one of her first museum exhibitions. She forged closer ties with the museum by persuading then Chief Curator Barbara Johns to mount a retrospective of Ken Cory's work in 1997, after his death in 1994. Worden and fellow artist Les LePere were the lead initiators and organizers of this exhibition. This project effectively expanded the scope of Tacoma Art Museum's collecting focus to include Northwest contemporary studio art jewelry. Nancy has helped raise funds to establish the Ramona Solberg Jewelry Endowment

FIGURE 1. *Beans in Your Ears,* 1996. Silver, copper-plated bronze, 14K gold, lapis, glass, petrified dinosaur bone, plastic, dried beans, copper coins, and laminated photographs, 24 (L) x 3 ½ (W) x ¾ (D) inches. Collection of the artist.

and represented the region's artists as a speaker at the museum's ground-breaking ceremony in 2001. She has continued to be a dedicated educator and active promoter of the museum's jewelry focus with subsequent exhibitions and programs.

Given her central role and voice in the tradition of Northwest jewelry art, she is a perfect subject for Tacoma Art Museum's *Northwest Perspective Series*, which celebrates the work of regional artists through an exhibition and accompanying catalogue. Since the series began in 2003, we have presented major exhibitions featuring Donald Fels, Mary Randlett, Akio Takamori, Michael Brophy, Howard Kottler, and Scott Fife. Originated as the *Twelfth Street Series* in 1993, the scope of the project has grown to include a scholarly publication and the purchase of work from the exhibition for the museum's permanent collection.

In addition to the *Northwest Perspective Series*, Tacoma Art Museum promotes artists of the Northwest by showing their work alongside that of artists from outside the region. Concurrent with *Loud Bones: The Jewelry of Nancy Worden*, Tacoma Art Museum hosts *Ornament as Art: Avant-Garde Jewelry from the Helen Williams Drutt Collection*, organized by the Museum of Fine Arts, Houston. This

exhibition is a broad survey of national and international jewelry art from the last thirty years and, notably, includes many artists from the Northwest—Ken Cory, Laurie Hall, Ron Ho, Mary Lee Hu, Keith Lewis, Kiff Slemmons, Ramona Solberg, Don Tompkins, Merrily Tompkins, and, of course, Nancy Worden—whose works are in Tacoma Art Museum's collection. By pairing these two exhibitions, we hope visitors will draw connections between regional artistic practice and its broader context.

Nancy Worden's clear vision helped guide us as we planned this exhibition, and we are grateful for the opportunity to work closely with her on this project. We also greatly appreciate the contributions of catalogue authors Dr. Susan Platt and Professor Michelle LeBaron, who spent many hours talking with Nancy about her work and crafting their essays. We are honored that esteemed gallerist and collector Helen Williams Drutt English contributed the foreword to the catalogue. Her insights into Nancy's work reflect her deep knowledge of jewelry and form a bridge between the two paired exhibitions. We thank Rock Hushka, our Curator of Contemporary and Northwest Art, for deftly bringing together all of the pieces necessary to organize the exhibition and produce the catalogue, Phil Kovacevich for his beautiful design work on the catalogue, and Pat Soden, Director of the University of Washington Press, for his support of the catalogue. We are also deeply appreciative of the support of our dedicated trustees, the generosity of the lenders to the exhibition, and the assistance of Traver Gallery, which represents Nancy Worden locally.

Finally, I offer our thanks to the sponsors of the exhibition and catalogue. The Guendolen Carkeek Plestcheeff Decorative and Design Arts Fund, which is administered and allocated by ArtsFund, provided much of the financial support necessary to undertake this project. Nationally renowned studio art jewelry collector and advocate Susan Beech demonstrated her extraordinary generosity and passion for jewelry art through her support of this project. Former Director of Tacoma Art Museum Janeanne Upp and her husband Dale Meyer also gave their support, which is a moving testament to their ongoing commitment to Northwest artists. We offer a heartfelt thanks to all of the aforementioned for making the work of Nancy Worden accessible to the community and helping to create a lasting legacy for Northwest art.

Nancy Worden in her studio, 2005

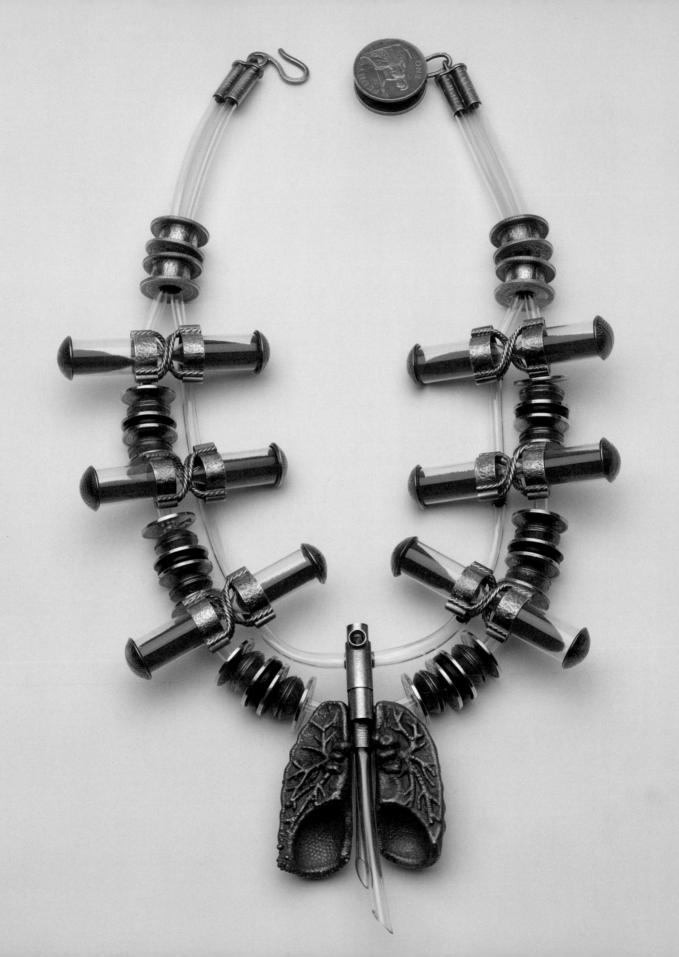

DIAL "N" FOR NANCY

Helen Williams Drutt English

> Ridicule has ever been the weapon of the weak; and to those
> of my sex who are convinced of the superiority of the new
> costume, but are hesitating to adopt it for fear of the "world's
> dread laugh," I would say, "be independent, and care nothing
> for it. . . . There is no form which does not become beautiful
> when it is found perfectly adapted to its end."
> —Lui Lundie, *The Lily*, August 1851

1954: The year the Supreme Court ruled that segregation by race in public schools is unconstitutional; the U.S. formally condemns and censures Joseph McCarthy; the U.S. begins involvement in Vietnam; Hemingway receives the Nobel Prize; Tolkien's *Lord of the Rings* and Golding's *Lord of the Flies* are published; Fellini's *La Strada* premieres; Colette dies; and Nancy Worden is born, in Boston, in the midst of a unique global, cultural, and political ferment.

Who is Nancy Worden? She has emerged from our Pacific Northwest to become a nationally recognized artist. Her assertive personality, bellowing voice, and laughter, which resonate in a room, combine with a socially embracing persona to present a unique

FIGURE 2. *Buying Time,* 1999. Copper, silver, brass, plastic, horn, sand, and Pyrex, 26 ½ (L) x 4 ³/₁₆ (W) x 1 ¼ (D) inches. Museum of Fine Arts, Houston, Helen Williams Drutt Collection, gift of friends of Barbara Paull in honor of her birthday, 2002.3656.

package of a woman. Nancy's self-explanatory writings, which complement her work, reveal her amazing insight and leave little need for an outside critic. She is fully engaged with her collectors as she balances a dedicated relationship with her gallery. Nancy is a careful plotter of her career.

Where do we place Nancy Worden's work in the panoply of ideas that form the history of American jewelry, or, better still, the history of American art? William C. Seitz, in the 1961 exhibition entitled *The Art of Assemblage*, chose the term assemblage to cover "all the forms of composite art and modes of juxtaposition." Assemblage is central to the work of Worden and her Pacific Northwest mentors in the field that altered our perception of traditional ornament. Ellensburg and Seattle artists Ken Cory, Ron Ho, Ramona Solberg, and Don Tompkins, as well as goldsmiths Robert Ebendorf, William Harper, and J. Fred Woell,

who worked outside of the Northwest, constitute the generation of artists that preceded Nancy. Among her contemporary Northwest peers, whose work is also dictated by narrative and assemblage positions, are Laurie Hall, Kiff Slemmons, and Merrily Tompkins. If we reach beyond our continent, we see that assemblage was also incorporated into the work of Australian Pierre Cavalan, as he surrounded his brooches with souvenir tacks in step like a Busby Berkeley chorus line, or such Europeans as Falko Marx, whose use of ancient shards and rusted cans encased in gold were enhanced with gems, and Bernhard Schobinger, who incorporated mundane objects like glass shards, plumbing hardware, rocks, identification tags, and found objects to critically challenge political and social issues.

How do we perceive the work of Nancy Worden? Idiosyncratic assemblages of familiar objects, boxes, coins, fur, bones, credit cards, mysterious elements under glass, plastic tubes, hourglasses, pens, and cast objects—what might seem incongruous suddenly appears formal and classical in the final juxtaposition of elements. The power of symbols weighs heavily on this artist. Her early memories and formative experiences inform her unconventional imagery with vigor and vitality. Her psychic gestures are frozen in materials that cannot move. Psychic identity not cultural identity is central to her soul; the ancient art of feeling endows her work as the concept of beauty is forever challenged. She has chosen to make her art—to breathe her art and to exhale it; her works challenge the private collectors who adorn themselves as she re-creates human experiences in an assemblage of personal references.

In Nancy's case, the moment of reflection moves through her psychological process and bears the anxiety of the traumas that surround her, giving physical heft to her work. The lexicon that expands her compulsive imagery targets one's consciousness. Titles like *Brigandine for Ishtar, Shackles of Fear,* and *Fortitude* deepen the impact of the work and demonstrate her desire not to let us go! During the past decades, her diverse range of artistic expression has incorporated subject matter that responds to human ailments. A gentle obsession in Nancy's spirit dictates that making art is a form of therapy or healing for her, or a method in which she can express her defiance of an unjust social action. For instance, *Buying Time* (1999; fig. 2, page 10) reveals her attachment to her mother as she transcends physical being. Angst as well as generous love within her marriage find solace in *Conjugal Bushwhacking* (2000; plate 27, page 87), and *Gilding the Past* (2001; fig. 43, page 59; plates 28–29, pages 88–89) references the raging public protest in response to free trade supported by the World Trade Organization.

Worden has the artist's special gift of being able to turn her pain into art: The memory of impending death, final and irrevocable death, marital strife, and political tensions are all visible. She purges herself through the journey of her psychic life; she cleanses her mental anxiety with, as Paul Celan states in *Gesammelte Werke*, the "aqua regra of reason—in the midst of despair a lung must learn to breathe again." She has assembled the disparate elements of memories and strife into a new concept of beauty and invites us, in our search, to dial "N" for Nancy.

Nancy Worden, 1998

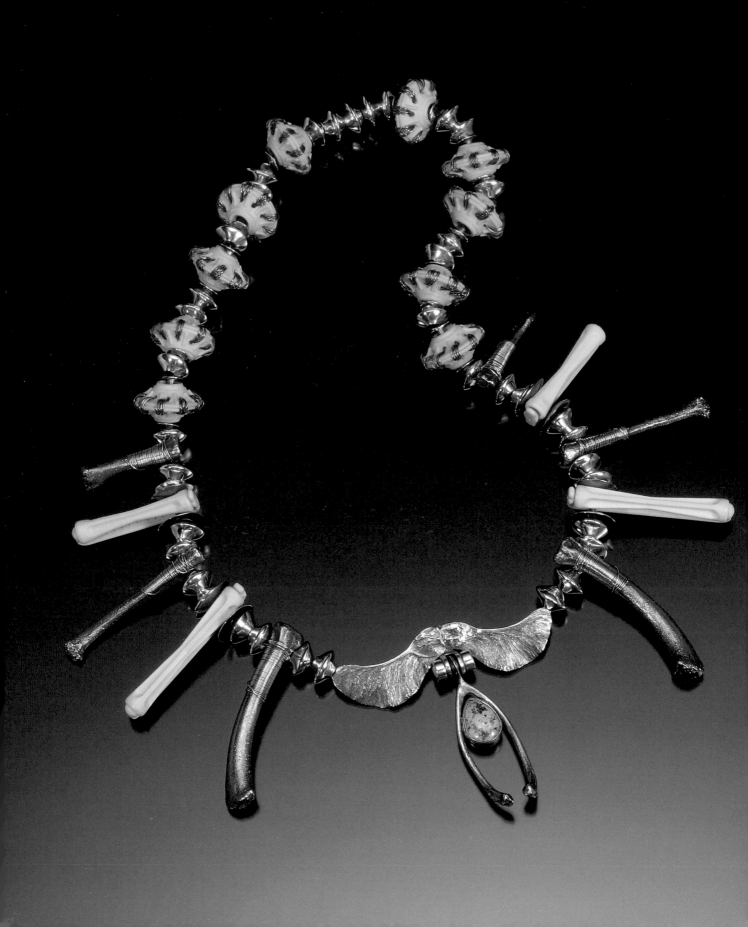

ADORNMENT, ARMOR, AND AMULETS:
THE ASTONISHING JEWELRY OF NANCY WORDEN

Susan Noyes Platt, Ph.D.

JEWELRY CONNECTS TO LIFE'S MEMORIES, seductions, vanities, sorrows, and celebrations. Body ornament, one of the oldest arts in the world, has been found in sites that date back thousands of years. Nancy Worden's jewelry builds on these ancient traditions and transforms them with modern techniques and materials. She reclaims mundane detritus from everyday life and makes it beautiful. Although her point of departure is often personal experience, Worden expands the content of jewelry with references to politics, history, and mythology that resonate with the realities of modern life.[1]

Born in Boston, Massachusetts, in 1954, Worden was raised in an academic family that valued literature, art, and politics. When she was still a child, her family moved across the country, first to Yakima and soon after to Ellensburg, in central Washington State. In spite of the pervading conservatism, they followed the civil rights movement and actively protested the war in Vietnam. Women in her family were encouraged to speak up, pursue a college degree, and lead an active professional life. These family traditions provide the bedrock for her career as an outspoken narrative artist.

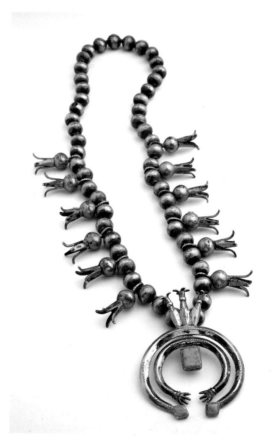

FIGURE 3. *Initiation Necklace,* 1977. Silver, rhodonite, copper, pills set in epoxy, and plastic hair curlers, 27 (L) x 3 (W) x 1 ¼ (D) inches. Tacoma Art Museum, Gift of the artist.

FIGURE 4. NAVAJO. Squash Blossom Necklace, 1890s. Silver and turquoise, 17 inches in length. Collection of the Heard Museum, Phoenix, AZ.

REFERENCE POINTS

Nancy Worden has a deep respect for earlier jewelry traditions as well as other cultural traditions, but as she draws on formal elements from many cultures and eras, she alters them by using contemporary techniques and per - spectives. Her first self-conscious historical reference was the result of a student assignment to investigate Native American jewelry design. *Initiation Necklace* (1977; fig. 3, page 14; plate 1, page 66) was her response, a contemporary translation of the traditional squash blossom necklace, which includes a crescent shape as the central pendant (fig. 4, page 15).[2] Throughout her career, Worden has repeatedly returned to this format, but she has always altered it with contemporary ideas and materials.

Another historical format adapted to new ideas is what Worden calls her Victorian "drippy" necklaces. *Which Way?* (1989; plate 4, page 68) alludes to this format with its multiple elegant swoops that drape over the chest. The humble found materials—plumber's chain, typewriter letters (N, S, E, W—hence the title), and the compass at the center— amusingly update the Victorian format.

In *Lifting Weights* (2004; fig. 5, page 16; plates 42–43, pages 102–103), Worden transforms the format from Victorian to Modernist. Instead of the Victorian elegance of looping chains, the effect is mechanical. Hanging from pulleys are lead weights that move when they are pulled. Stamped texts on the lead weights literally balance the needs of others with those of the wearer. In the front are the words "I want," "I need," "I should," "I mustn't." In the back the weights read "they want" and

"they need." In contrast to *Which Way?*, where the directions are literally spelled out, *Lifting Weights* offers conflicting messages. In contrast to Victorian women's clearly established social norms, many modern women lack clear guidelines for dealing with multiple pressures.

The elegant art nouveau jewelry of René Lalique (1860–1945) provides another reference point for Worden's jewelry. Lalique used a variety of materials and techniques combined with precious stones and metals to suggest nature and eroticism. Worden pays homage to Lalique with her brooch *A Funny Feeling* (1994; fig. 6, page 17), but she combines the art nouveau elegance of a sinuous cast-silver vine and a dangling pearl with a highly personal

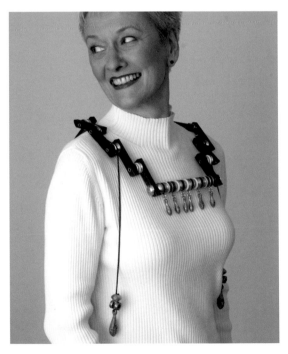

FIGURE 5. *Lifting Weights,* 2004. Silver, 14K white gold, lead weights, brass, glass eyes, ebony piano keys, bone, horn, cotton cord, and coins, 20 (H) x 10 ½ (W) x ¾ (D) inches. Collection of Susan Beech.

choice of cloves and tacks set in an ordinary eyeglass lens. This contradiction of the beautiful and the uncomfortable is one trademark of Nancy Worden's jewelry.

Worden's ability to combine odd materials into harmonious forms is based in a perspective that she acquired in her earliest years. Worden's first jewelry teacher was Kay Crimp, who was teaching in her high school in Ellensburg, Washington. Crimp was a student of Ramona Solberg (1921–2005), an internationally renowned jeweler based in the Northwest, who lived and taught in Ellensburg for many years. Solberg was known for her bead and assemblage necklaces that incorporated materials and objects she found on her many trips abroad. These pendants and necklaces were the first real studio jewelry Worden ever saw.[3] Worden pays formal homage to Solberg in *The Good Omen* (2004; plate 40, page 99). The beads, evoking a modernist arch, are filled with rusted steel that create contrasting textures and tones; chunks of aggregate from the destroyed King Dome sports stadium in Seattle also found their way into some of the beads. While the formal shapes salute Solberg, the metaphor of the necklace is characteristic Worden. *The Good Omen* captures her exuberance when she surprised a flock of bright blue butterflies that she came upon at a time when she was depressed. Asymmetrically scattered over the modernist segments are silver ears that honor the psychologist who helped her overcome depression.

Nancy Worden's jewelry has deep roots in her study from 1972 to 1978 with Ken Cory (1943–1994) at Central Washington University. Cory's jewelry was often technically experi -

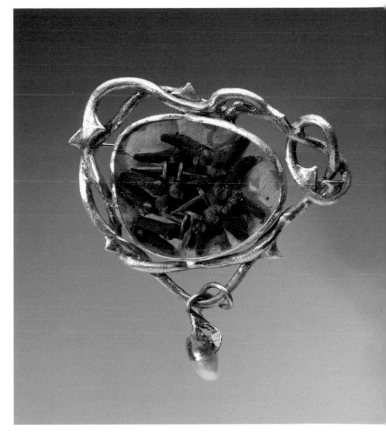

FIGURE 6. *A Funny Feeling,* 1994. Silver, pearl, glass, paper, steel tacks, and dried cloves, 3 ½ (H) x 3 (W) x ¼ (D) inches. Collection of the artist.

mental, but extremely refined. His small-scale pins suggest subtle archetypal forms with scrupulously crafted precious metals (fig. 7, page 18). He carefully planned his work through dozens of preliminary sketches. Simultaneously with his personal work, Cory collaborated with graphic artist and painter Leslie LePere as the Pencil Brothers. Together, they celebrated popular culture by creating small-scale works that suggest both a deep love of the natural world and an irreverent humor that resulted in quasi-surrealist fantasy images. Cory loved practical jokes and explicit male

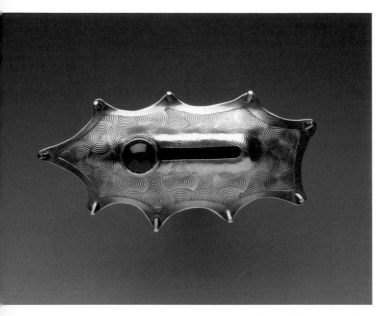

FIGURE 7. KEN CORY, *Tent,* 1988. Silver, gold, and carnelian, 1 ¼ (H) x 2 ½ (W) x ½ (D) inches. Tacoma Art Museum, Gift of the Estate of Ken Cory.

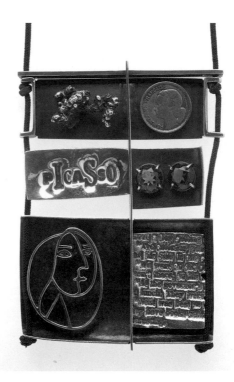

FIGURE 8. DONALD TOMPKINS, *Picasso,* circa 1970s. Silver, synthetic stones, cotton cord, and copper coin; pendant: 4 ¾ (H) x 3 ¼ (W) x ½ (D) inches. Collection of Judith A. Whetzel.

sexual overtones. In contrast, Worden's humor is laced with feminine imagery and references to the dark side of life.

Don Tompkins (1933–1982) is another Northwest artist who provided a point of departure for Nancy Worden. In the late 1960s Tompkins worked with Ramona Solberg at what was then Central Washington State College. His large Pop-influenced pendants and brooches with direct references to contemporary celebrities (fig. 8, page 18) are sometimes echoed in Worden's work. *Silence is Golden* (1998; fig. 9, page 19; plate 24, page 83) is Worden's conscious salute to Tompkins. The main pendant of the necklace is a vintage black and white rotary phone dial, with a cast-metal mouth in the center. The cast mouth echoes a Tompkins motif as does the cut-out gold bubble stamped with "silence is golden."

The necklace itself has tongue-shaped red stones and coiled telephone cord from old-fashioned phones. *Silence is Golden* is also about telephone solicitors and the incessant noise of the media.

In 1970 the exhibition and book *Objects: USA* defined the American Studio Craft Movement. It is still a definitive source on this subject. It included such now well-known artists as ceramist Peter Voulkos, glassblowers Harvey Littleton and Dale Chihuly, fiber artist Lenore Tawney, and jewelers Ramona Solberg

FIGURE 9. *Silence is Golden* (detail), 1998. Silver, 18K gold, carnelian, rubber, laminated photograph, and old telephone parts, 19 (L) x 3 ¾ (W) x 1 (D) inches. Collection of Marion Fulk.

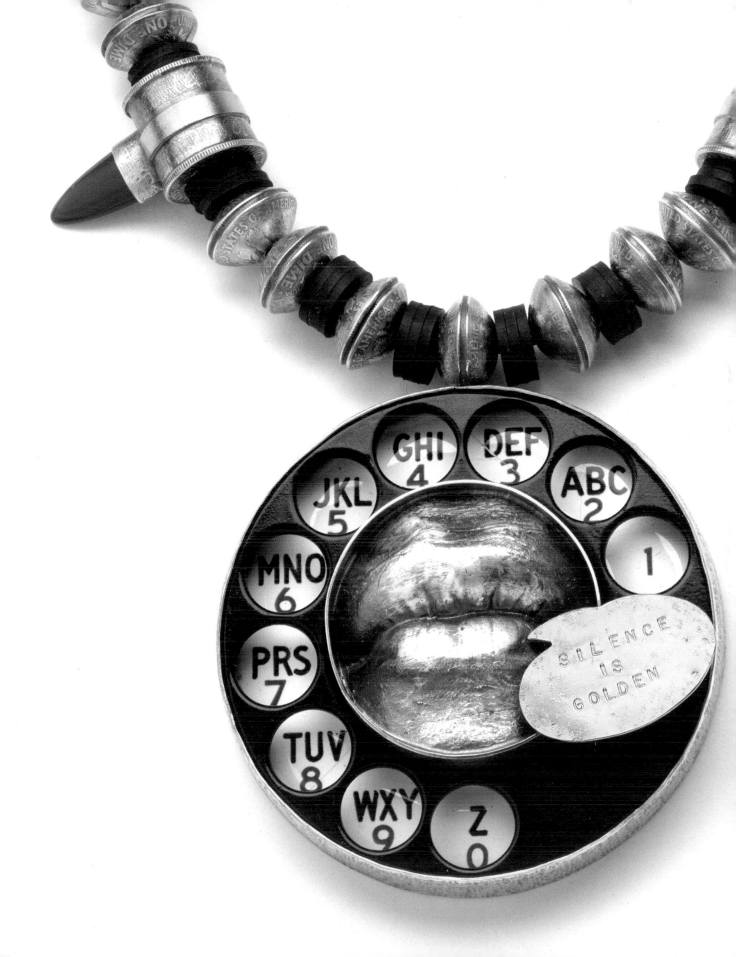

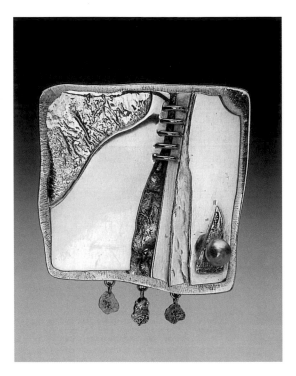

FIGURE 10. OLAF SKOOGFORS, *Brooch*, 1973. Gold-plated sterling silver and blue baroque pearl, 2 ⅜ (H) x 2 ⅛ (W) x ¾ (D) inches. Museum of Fine Arts, Houston, Helen Williams Drutt Collection, Gift of the Caroline Wiess Law Foundation, 2002.4096.

and Ken Cory.[4] These artists expanded the possibilities of traditional craft materials as they participated in the conversation defining what is American in American art.

When Worden was a student, modernist jeweler Olaf Skoogfors (1930–1975) was widely admired for his technical and formal innovations. As a metalsmith, he excelled in soldered lines that created framing devices and "wrinkled" surfaces based on careful control of heated metal surfaces (called reticulation). He added precious stones to his sculptural metal pins for texture and color (fig. 10, page 20).[5] Worden still playfully borrows his trademark hanging pearl or gemstone.

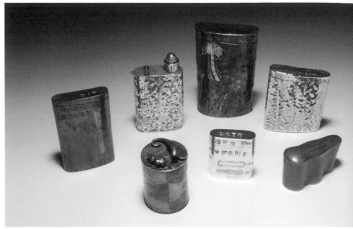

FIGURE 11. GARY NOFFKE, selection of containers, 1972–1982. Copper, brass, sterling, fine silver, fine gold, and ivory, heights vary from 1 ¾ to 4 inches. Courtesy of the artist.

Worden's graduate training with Gary Noffke at the University of Georgia expanded her technical proficiency. Approaching form and process like a potter, Noffke explores the same forms over and over, like variations of a musical theme (fig. 11, page 20). In contrast to the systematic approach of Cory, he encouraged Worden to work rapidly and intuitively with materials.

Following graduate school, Worden worked for five years in the male-dominated world of jewelry manufacturing, an intense and demanding experience that exponentially increased her technical proficiency. Worden was mentored by skilled tradesmen who could make almost any kind of jewelry imaginable. At the same time she herself was introduced to the realities of the working world for women.

MATERIALS AND TECHNIQUES

Precious metals and stones have always been basic materials for jewelry. In Worden's jewelry,

these elegant materials are combined with scrap metal, concrete, plastic, and glass found in the street. But Worden goes a step further. She also works with a dizzying array of found materials selected for their textures, shapes, tactile qualities, and, most importantly, their associations.

Found materials are sometimes selected from what she calls her "accumulations," collections of discarded objects like bottle tops, clothespins, eyeglass lenses, credit cards, scraps of metal, tire weights, cigarette butts, wishbones, fortunes from cookies, souvenir pennies, champagne corks, and electric typewriter balls. She also collects old phone parts, rifle shells, coiled steel wire and electrical insulators, oven thermometers, clocks, and watches. Barbie Doll arms and the scaled-down organs from the anatomical model known as the "Visible Woman" serve as the sources for models that become electroformed body parts.

Even in her earlier works Worden displays the ability to combine a variety of unpredictable materials. A baroque-looking wisdom tooth and cast-gold crown in *Venetian Vacation* (1986; fig. 12, page 21; plate 3, page 67) combine with smashed "Add-a-Beads," ear-like shells, and pearls dangled on spiraled gold.[6] The effect is simultaneously lush and annoying, similar to the aesthetic of the overelaborate containers for religious reliquaries. *Eyelet Lace* (1984; plate 2, page 67) combines slick greenish plastic and quartz with cast lace. The old plastic frames introduce odd colors and strange shapes that suggest eerie mysterious powers.

Narratives and metaphors drive Worden's choice of materials and techniques. She selects materials according to her concept for a partic-

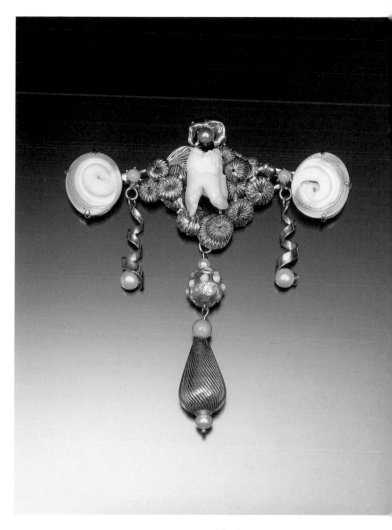

FIGURE 12. *Venetian Vacation,* 1986. 14K gold, glass, pearls, shell, turquoise, and wisdom tooth, 3 ⅛ (H) x 3 ½ (W) x ½ (D) inches. Collection of Mia McEldowney.

ular piece of jewelry. For example, in *Balancing Right and Left* (2000; plate 26, page 85), a straightforward symmetrical necklace, hard electroformed beads based on miniature brains alternate with watercolor brushes made from the soft hair of a mongoose spread out like flowers. The materials as well as the balance of the composition convey a metaphor for an

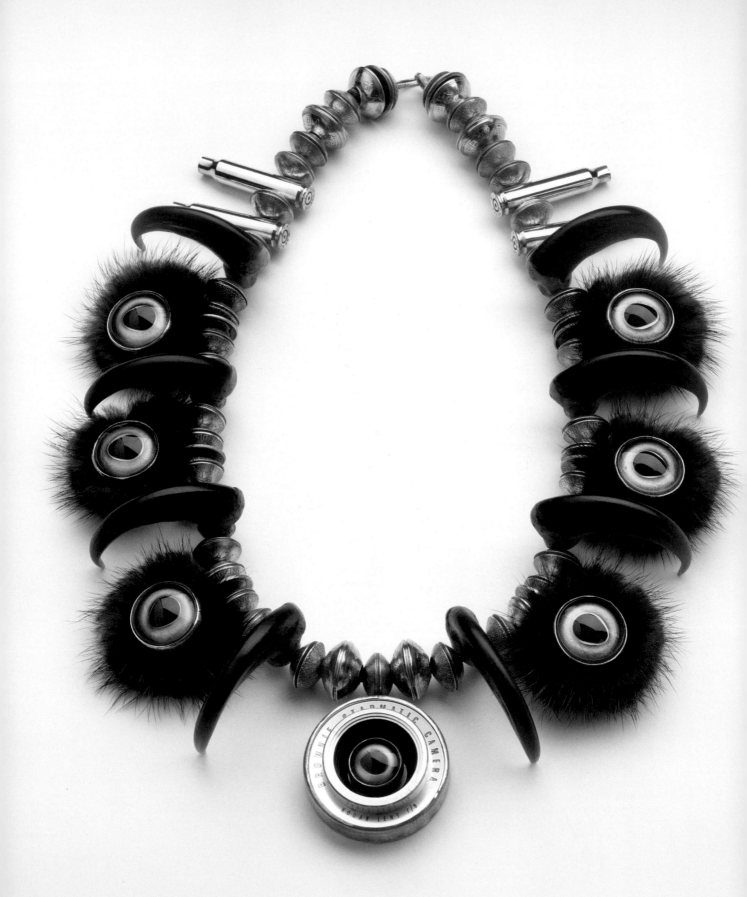

exactly alternating rhythm of the left and right brain, the intellectual and the intuitive.

Beans in Your Ears (1996; fig. 1, page 6; plate 17, page 75), constructed from eyeglass lenses used as settings for dried beans, is a delightful variant on the squash blossom format. Worden chose eyeglass lenses to invoke an age-old jewelry tradition of protecting an "artifact" under glass and a subtle reference to eye amulets that protect the wearer.[7] In *Beans in Your Ears*, the lens-covered artifacts alternate with cast-bronze and silver ears inset with a single blue lapis bead. The pendant has a larger bean-filled lens, blue plastic earplugs, and pointed ears made of dinosaur bone. Enumer-ating all the materials underscores a primary Worden characteristic, a willingness to use any-thing that gets her point across. Taken together, the materials construct a narrative based on Worden's experience as PTA president—she often presided over meetings where everybody was talking and nobody listening.

Another example of materials that drive a narrative is *Dead or Alive* (1997; fig. 13, page 22; plate 19, page 77). It uses resin bear claws and found scraps of fur punctuated by glass fish eyes from a taxidermist. The composition echoes traditional Native American grizzly bear claw necklaces (fig. 14, page 23).[8] Worden in-tends the necklace to be empowering, but in a contemporary substitution, her fur comes from thrift shops, rather than as a result of prowess in hunting (other than hunting in thrift shops).

FIGURE 13. *Dead or Alive,* 1997. Silver, brass, resin bear claws, mink, glass taxidermy eyes, leather, camera parts, and laminated photograph, 24 (L) x 2 ¾ (W) x 1 ½ (D) inches. Seattle Art Museum, Anne Gould Hauberg North-west Crafts Fund and the Mark Tobey Estate Fund.

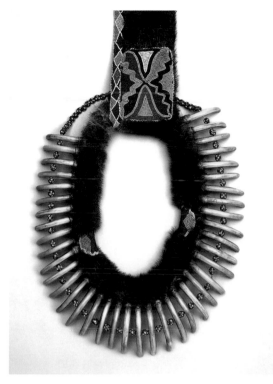

FIGURE 14. MESQUAKIE. Bear Claw Necklace, c. 1835. Bear claws, fur, glass beads, ribbon, horsehair, and cloth, 67 ½ (L) x 14 (W) x 4 (D) inches. The Detroit Institute of Arts, Founders Society Purchase with funds from Flint Ink Corporation (81.644).

The necklace also includes bullet casings and beads made from dimes. A camera lens at the center adds another metaphor. The necklace is about the human need to both kill and take a souvenir from a wild creature.[9]

Worden's choice of technique is as inten-tional and wide-ranging as her use of materials. She sometimes combines casting, fabricating, assemblage, electroforming, and other tech-niques in a single work. Perhaps the most unusual technique in this list is electroforming, in which metal is added to a form by use of an electric current.[10]

Worden first used electroforming in the se-ries *The Importance of Good Manners* (1995;

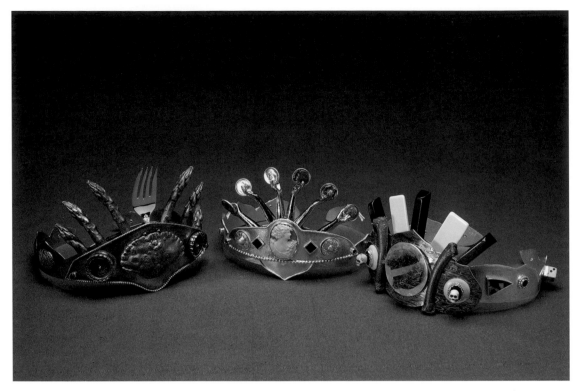

FIGURE 15. Left to right: *Hospitality Tiara, Charity Tiara,* and *Politically Correct Tiara,* 1995, from the series *The Importance of Good Manners. Hospitality Tiara:* silver, copper, shell, pearls, hematite, and beer bottle caps, 5 (H) x 6 ½ (W) x 7 ½ (D) inches. *Charity Tiara:* silver, gold-plated copper, shell cameo, moonstone, and onyx, 4 ½ (H) x 6 ½ (W) x 7 ½ (D) inches. *Politically Correct Tiara:* silver, copper, onyx, jasper, ivory, bone, ebony, and fur, 4 ½ (H) x 6 ½ (W) x 7 ½ (D) inches. Seattle City Light 1% for Art Portable Works Collection.

fig. 15, page 24; plates 14–16, page 74), three tiaras made for the City of Seattle. The technique enabled her to enlarge her forms without increasing their weight. *Hospitality Tiara* is about food. *Charity Tiara* refers to philanthropy. *Politically Correct Tiara* blatantly breaks rules with politically charged materials like elephant ivory, ebony, and fur. In contrast to the heavy spirit of the tiaras, *Gilding the Past* (2001; fig. 43, page 59; plates 28–29, pages 88–89), also electroformed, is cheerful and light, with alternating gilded peace symbols and happy faces in a double strand of coral, turquoise, and coin beads. The two strands are connected by gilded electroformed bones.

Electroforming can also create distance from the original found object. *Initiation Necklace* (1977; fig. 3, page 14; plate 1, page 66) and *Exosquelette #1* (2003; plates 33–34, pages 92–93) both include hair curlers, but in the first they are easily recognized, and in the second they are electroformed into a subtle repeated pattern that takes on a second meaning as vertebrae-like bones. Combined with carefully set eyes both front and back, the hair curlers become a protective device.

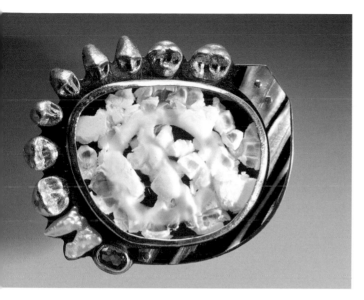

FIGURE 16. *Resolution to Lose,* 1992. Silver, citrine, pearl, popcorn, glass, cloth, and paper, 2 ¼ (H) x 2 ½ (W) x ⅜ (D) inches. Collection of the artist.

RITES OF PASSAGE

One of jewelry's traditional functions has been to commemorate a rite of passage. Worden's jewelry connects to her own passages as a young girl, a woman, a mother, a friend, a daughter, a granddaughter, and a wife in the United States of the late twentieth century.

Initiation Necklace honors her maternal grandmother, who insisted that Worden dress as a proper young lady, including permed hair, when she reached adolescence. This oddly elegant necklace incorporates two types of pink hair rollers to form the characteristic squash blossom shape. Made in 1977 when women's liberation rejected traditional feminine actions, colors, and forms, the necklace makes a defiantly feminine statement with its pink hair curlers.

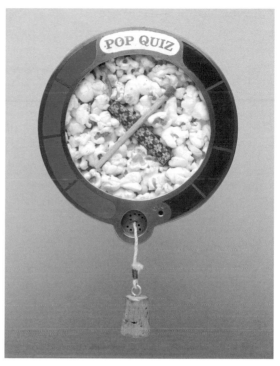

FIGURE 17. PENCIL BROTHERS, *Pop Quiz,* 1973. Enamel on copper, glass, popcorn, cork, wooden match, and fire-cracker, 6 ¾ (H) x 4 ¼ (W) x ¾ (D) inches. Collection of Leslie LePere.

Even more playfully referring to a rite of passage is *Resolution to Lose* (1992; fig. 16, page 25), an eyeglass-format brooch full of popped popcorn with a cancellation sign etched across the glass. The popcorn was shamelessly borrowed from the Pencil Brothers's *Pop Quiz* (1973; fig. 17, page 25) because Worden liked its formal color relationships. In contrast with the Pencil Brothers's lighthearted pun on firecrackers and academic tests, Worden refers to weight loss—here the baby fat that she gained while she was pregnant.

Planning for our children to receive an inheritance is another rite of passage.

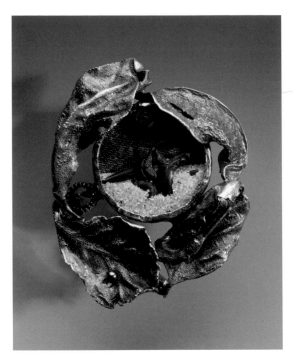

FIGURE 18. *Hidden Agenda,* 1994. Silver, hematite, pearl, glass, sand, silk, and shark teeth, 2 ½ (H) x 3 (W) x ¾ (D) inches. Collection of Susan Beech.

Conflicts over inheritance can be an intense process that brings out the worst in families. Worden has addressed this issue in several works, particularly *Hidden Agenda* (1994; fig. 18, page 26; plate 12, page 72), an odd, ugly brooch with shark's teeth floating in sand in its circular center. In the leaves that frame it, a gun lurks. It suggests a dark, paranoid mood.

Family Fortune (1994; plate 11, page 72) addresses the more specific situation that artists frequently have little to leave in traditional wealth. The necklace is built from eyeglass lenses used as settings for Chinese fortune cookie fortunes alternating with gold wishbones. The work invokes the idea of

superstition and false hopes. For Worden, it also represented another rite of passage—as she made it, she came to realize that what artists leave their children are intangibles like a love of art, rather than a monetary inheritance.

Mourning jewelry commemorates death and loss, the most profound rite of passage. During Queen Victoria's reign, after the death of Prince Albert, it became common for women to wear jewelry that commemorated lost ones, either with a lock of hair, or chains and brooches fashioned from black materials like jet, bog oak, and vulcanite. Worden collects some of this "hair jewelry" and has even created brooches that incorporate hair, one of the parts of the body that never rots. But she has also expanded mourning jewelry beyond lockets and medals.

Commemorative and mourning jewelry assumed profound significance for Worden when Ken Cory died unexpectedly of undiagnosed diabetes. *Out of My System* (1994; fig. 19, page 27) refers directly to the cause of his death. The brooch's heart shape is completed by plastic tubing on one side, referring to medical supplies. Inside are a cast kidney charm and a kidney bean. Red coral evokes an aorta, and the baroque pearl suggests a mystery organ. The brooch seems to be ripped open, with the inside of the heart exposed. It takes commemoration and mourning to a level of intensity that is socially unacceptable. This small brooch declares itself as an interruption in the silence

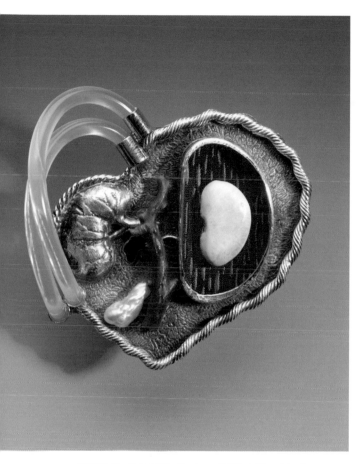

FIGURE 19. *Out of My System*, 1994. 18K gold, silver, coral, pearl, plastic, silk, glass, and painted bean, 2 ¾ (H) x 2 ¾ (W) x 1 ⅓ (D) inches. Collection of Carol Bobo.

that veils illness, organs, and the physical body in a state of malfunction.

The same can be said of *Buying Time* (1999; fig. 2, page 10), which commemorates Nancy Worden's mother who died of ALS (Amyotrophic Lateral Sclerosis), also known as Lou Gehrig's disease. The artist's grandmother, mother, and sister have all died of ALS. In this poignant work of commemorative jewelry, the necklace itself is made of two strands of plastic tubing from a venti-lator. The central pendant has small metal lungs with a tracheotomy tube inserted. Glass egg timers filled with red sand suggest that ventilators just buy the patient a little time. The mostly horizontal position of the timers means that as the wearer moves, the sand may or may not move; life may or may not run out.

RELATIONSHIPS

Much of Worden's jewelry is about experiences between people that defy traditional limitations for women and assert new possibilities. The *Middle-Aged Mom* series of the early 1990s directly addresses women's place in the world. This group of works represents an important turning point for the artist. It was produced in response to her sudden understanding that she had been limiting her jewelry to the traditional functions of ostentatious display and decoration. The event that led to that realization was designing *Pounding Hearts, Singing Feet*, an exhibition of Eastern European dance costumes, for the Northwest Folklife Festival in 1991. As she listened to stories about the histories of the costumes from the women who owned them, Worden had an urge to reconnect her artwork with her own stories.

She decided to return to her "idea" training with Ken Cory by carefully choosing unusual materials that had personal resonance. The desire to redirect her art was affirmed by a grant from Artist Trust that enabled her to make the *Middle-Aged Mom*

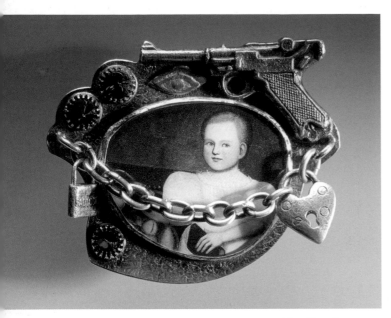

FIGURE 20. *Overprotective Impulse,* 1993. Silver, brass, glass, onyx, and paper, 2 ¼ (H) x 2 ¾ (W) x ½ (D) inches. Collection of the artist.

series that includes *Runnin' Yo Mama Ragged, Overprotective Impulse, Bathroom Bowl Blues, I Feel Pretty, Nights in Shining Armor*, and *Mixed Messages*. The titles alone tell us that Worden is commenting on the craziness of parenting, conflicting views of child-raising, and the contradictions of what we expect and what we get.

Runnin' Yo Mama Ragged (1992; plate 7, page 70) is built around a purple watch face surrounded by castings of small shoes from dolls. The shoes can be spun around the clock face, a humorous outlet for the harried mother racing from one event to another. Yet, this mother keeps hold of her dignity; the brooch has inset amethysts and the shoes are cast in silver. Whatever is coming down on this family is going to be coming down in style.

In *Overprotective Impulse* (1993; fig. 20, page 28; plate 10, page 71), Worden places a reproduction of a folk painting of a stiffly seated, overdressed young girl surrounded by pieces of fruit behind an eyeglass lens. A chain crosses in front, hanging from a heart at one end and a padlock at the other. Even more protection comes from a gun, an all-seeing eye, and spiky stones. The brooch dates to when Worden's own daughter was growing up, but the theme would be familiar to any mother.

The last three works in this series are more obviously feminist as well as humorous. *Nights in Shining Armor* (1994; fig. 34, page 48) has a bright pink condom and a penis-shaped pearl next to a small cast "knight" and a "lifesaver." This outrageous work says to forget getting saved by men from your follies, and be prepared to take care of yourself. *Bathroom Bowl Blues* (1992; fig. 33, page 48; plate 5, page 68) has a little brush curving over the top and a sponge behind the lens, a hilarious reference to the humblest of household chores.

I Feel Pretty (1993; plate 8, page 70), with its fake fingernails, an eyelash set on vintage lace, and a little cast ballerina, directly commemorates a prom organized for Worden's fortieth birthday. But the brooch is beautifully designed, asymmetrically weighted, ironic, funny, and serious all at the

FIGURE 21. *Repairing the Nest,* 1999. Copper, silver, gold plate on copper, and glass eyes, 28 (L) x 3 ½ (W) x 1 ¼ (D) inches. Collection of Judith A. Whetzel.

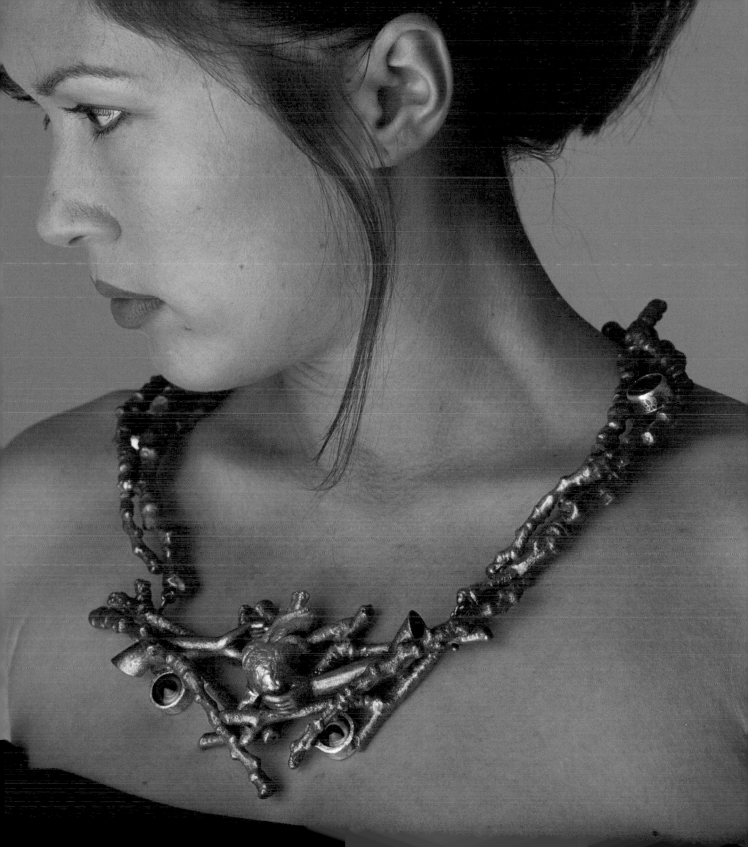

same time. With ultra-feminine materials, it revels in femaleness as much as feminism.

In contrast to the low-relief brooches, necklaces like *Repairing the Nest*, *Conjugal Bushwhacking*, and *Grafting* are more sculptural, but they are equally layered with contradictions. While they appear elegant, the branch-like forms address conflicts between people. *Repairing the Nest* (1999; fig. 21, page 29; plate 25, page 84) suggests a circular nest with electroformed branches based on cottonwood sticks. Made when the artist and her husband were remodeling their home, a time when many couples break up, it suggests the idea of reconstructing a relationship. *Conjugal Bushwhacking* (2000; plate 27, page 87) has a dominant pendant that interlaces silver and copper branches with tangled arms. Worden is suggesting that energetically clearing underbrush is a metaphor for clearing the air. The rest of the necklace is composed of chunky lava beads, actively engaging the wearer in the discomfort of the situation. The silver branches of *Grafting* (2001; fig. 42, page 58; plates 30–31, page 90) wind around the neck like tentacles; they sprout solid-gold cast ears, hearts, and arms, representing the capacity of the human brain to branch out in new directions.

Electric Fence (2007; plates 46–47, pages 106–107) is made of coiled wire and tubes from old-fashioned electrical wiring. At the center is a cow's vertebrae bone, a literal and metaphorical backbone. Its emphatic materials are confrontational, preventing physical contact by their real-life scale and creating melodrama with their unexpected juxtapositions. Based on the artist's childhood memories of getting shocked from an electric fence on a rural farm, the work is both very direct and brilliantly evocative of the idea of fear of intimacy.

POLITICAL THEMES

While personal politics are evident in most of Worden's work, her experiences often become metaphors for comments on society in general. *The Seven Deadly Sins* (1994; figs. 44–45, pages 60–61; plate 13, page 73) was stimulated by a disagreement with a neighbor, but Worden translated it into a darkly humorous exposé of the prominence of vice in popular culture. The necklace has eyeglass-lens units that each refer to a sin: envy–green eyeballs, sloth–broken jewelry blades, gluttony–Hershey's Kisses wrappers, lust–brass screws, wrath–broken glass, avarice–credit cards, and greed–fake rubies. In between each lens a small cast-silver devil's head creates the alternate bead rhythm. On the back of each lens, mounted in a "flaming" setting, is a photograph of a celebrity with his or her assigned sin: envy–Bo Derrick, sloth–Zsa Zsa Gabor, gluttony–Elvis Presley, lust–Woody Allen, wrath–Lorena Bobbitt, avarice–Leona

FIGURE 22. Left: *Hologram Theater*, 1998. Silver, 14K gold, onyx, and credit cards, 8 (L) x 2 ½ (W) x ½ (D) inches. Collection of Laura Oskowitz. Right: *Hologram Hell*, 1998. Silver, onyx, and credit cards, 8 (L) x 2 ½ (W) x ½ (D) inches. Collection of Lynn and Jeffrey Leff.

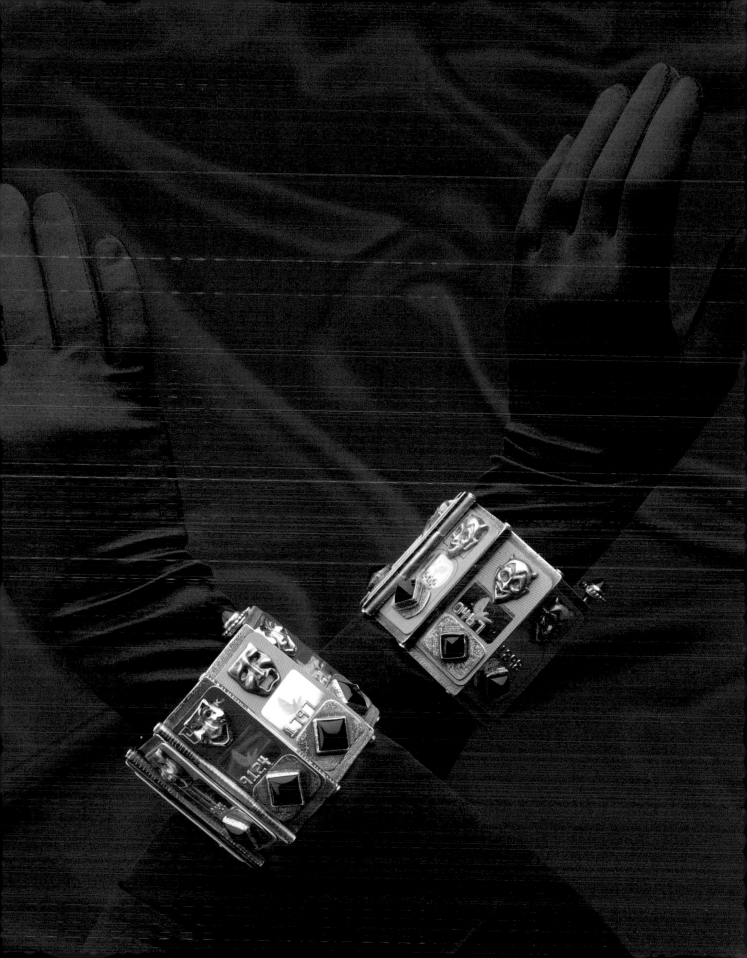

Helmsley. Linking celebrities in our society to biblical vices can also be read as a metaphor for the general dysfunction of our social and political world.

The same devil heads show up again in *Hologram Hell* (1998; fig. 22, page 31; plate 23, page 82), a work Worden designed by asking herself what a modern slave bracelet would look like. Her answer was, not surprisingly, a bracelet based on credit cards. Each silver link of the bracelet has a partial credit card, a bezel-set onyx stone, and a devil's head cast in gold. *Hologram Theater* (1998; fig. 22, page 31; plate 23, page 82) uses the same materials, but with gold comedy and silver tragedy masks molded from toy charms. With *The Seven Deadly Sins* and the two *Hologram* bracelets, Worden incorporates a different kind of found object— that of commercial and popular culture—by using credit cards and portraits of celebrities. She wickedly identifies consumption based on credit as the newest form of economic enslavement.

Armed and Dangerous (1998; plate 21, page 79) suggests the fear and anxiety that can sometimes give religion an evil power over people's lives. Using a squash blossom format, the necklace includes a pendant that is an oversized cross stuffed with money. The necklace is made of rifle shells that hold black onyx bullets and green stones the color of money. The work is a reference to a Christian fundamentalist group that directly affected Worden's family. But notwithstanding its sim-

plicity, the imagery of *Armed and Dangerous* still suggests a loaded threat.

In addition to fear and the power of religion to exploit it, Worden addresses fear of poverty and the greedy pursuit of money in *Broken Trust* and *Diamonds and Lust*. *Broken Trust* (1992; plate 6, page 69) puts real cut-up money behind glass lenses, half of which are broken on purpose, alluding to the erosion of trust in the federal government. Although made many years ago, *Broken Trust* could not be more apropos to our current economic meltdown.

Diamonds and Lust (1998; fig. 23, page 33; plate 22, page 81) refers to the greed of sports team owners that diverts money from the basic needs of ordinary citizens.[11] The main motifs of the necklace emphasize the supremacy of money in our national pastime. The pendant, in the shape of a baseball diamond, is stuffed with money; an elegant pearl hangs from a small gold baseball bat. On either side of the pendant are three gold-plated arms holding coins. On the back, pierced letters read "PLAY BALL." The overall effect is both elegant and humorous.

As Worden observed people's vindictive behavior after 9/11, she made *Vicious Circus* (2002; plate 32, page 91). Referring to the calls for revenge, the beads are cast-silver mouths with gold-plated serpents' tongues snapping out. The snake mouths alternate with multicolored star beads, and the clasp is in the shape of a clown face. This "vicious circus" of serpents and clowns evokes the

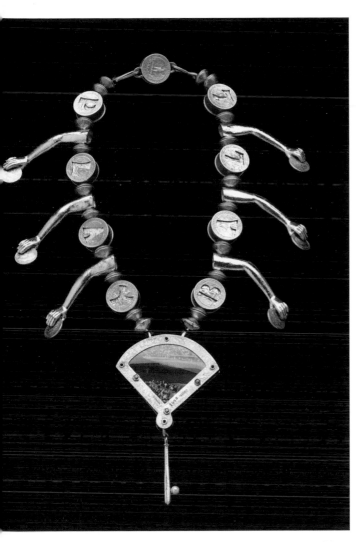

FIGURE 23. *Diamonds and Lust* (back), 1998. 18K gold, silver, 22K gold settings, gold-plated copper and silver, pearls, money, candy wrappers, and laminated photograph, 23 (L) x 5 (W) x 1 (D) inches. SM's - Stedelijk Museum 's-Hertogenbosch / NL.

other and encircle the neck, suggesting collaboration and community.

Terminology (1996; frontispiece; plate 18, page 76) comments on misunderstandings that can result from careless speech in a public sphere. Old-fashioned IBM Selectric typewriter balls alternate with flat, silver pill-like shapes. The work is reversible; wearers can choose to expose politically correct terms or rude epithets according to their mood and company. For example, on one pill, it says "fat" on one side and "pleasantly plump" on the reverse. Other beads refer to sex, gender, race, swearing, and politics. As Worden explains, "*Terminology* came out of years of attending community meetings in the most

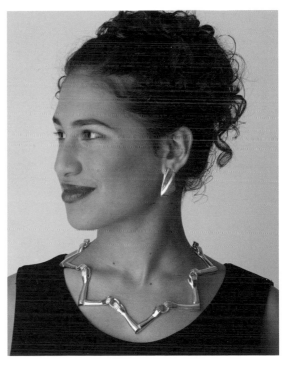

FIGURE 24. *Circle Dance,* 2001. Sterling silver, 24 (L) x 2 (W) x ¼ (D) inches. Collection of the artist.

cacophony of uninformed and hateful conversations that erupted after the attack on the World Trade Center. Also from the post-9/11 period, but saluting the opposite spirit, is *Circle Dance* (2001; fig. 24, page 33), a necklace of cast arms that hold on to each

diverse legislative district in the state and observing misunderstandings arise from unfortunate word usage."

The necklace format is dramatically expanded to an armor-like neckpiece with *Literal Defense* (2007; fig. 31, page 42; plate 48, page 109). Although this work mainly lies on the shoulders, rather than the chest, it evokes the steel breastplates of medieval soldiers. Painstakingly stamped on the entire surface are quotes from various authors who champion the arts and art education.[12] Upended typewriter balls with fish eyes are both a jagged threat and a protective device. Worden dedicated *Literal Defense* to the armies of art teachers that do daily battle with those who consider art education superfluous.

FEMINISM

As already suggested, feminism informs much of Worden's jewelry and sometimes it is the main subject. Her jewelry is primarily designed for and worn by women. Historically, in the United States, men have purchased expensive jewelry for women as a sign of love or appreciation. But as women have gained wealth and independence, they have become buyers of jewelry for themselves. If a woman chooses to wear a Nancy Worden necklace, she makes a statement about herself, her confidence, and often her politics.

The *Middle-Aged Mom* series is one starting point for thinking about this aspect

of Worden's work. From a later era in her life, at the advent of her fifties, she observed many women her age abandoning earlier ambitions, a condition she refers to as "spiritual osteoporosis." *Lifting Weights* (2004; fig. 5, page 16; plates 42–43, pages 102–103) and *Grafting* (2001; fig. 42, page 58; plates 30–31, page 90) were intended to empower women to achieve their goals.

The delightful *Frozen Dreams* (2004; fig. 25, page 35; plate 41, page 101) suggests liberation in its playful absurdity. At its center are facing high heels, nickel-plated to make them appear cold and frozen. Eyeglass lenses cascade over the shoulders front and back in a great pileup that jangles on the body. The work's bold presence encourages anyone wearing it to break up the ice freezing over her hopes and dreams and get on with her life.

The Leash (2003; plate 38, page 97), made of oversized clumps of mink and real pearls, salutes the present and future for women. This necklace references the trophy wife, ridicules it, and declares that women have moved on, all at the same time. The exaggerated puffs of mink, the pearls, and the long extension down the back are all parodies. The pearl and gold extension can be a whip or, according to the whim of the wearer, removed entirely.[13]

Transfer of Power (2005; fig. 26, page 36) revisits the format of the bear claw necklace, substituting nail extensions for bear claws and hair extensions for animal fur. The main motif that anchors the necklace is

loomed seed beads from Native American souvenir belts. They encircle the neck and continue with a long tail on the back. The components of female beautification, like nails and hair, are bound together with a kitschy decorative technique. In spite of the heavy title, the work is a lighthearted celebration of feminine ornamentation.

The two *Exosquelettes* are both assertively feminine and feminist. The electroformed hair curlers in *Exosquelette #1* (2003; plates 33–34, pages 92–93) form an exterior backbone to empower the spirit; yet, as the wearer walks, it playfully sways back and forth like a long ponytail or braid. In *Exosquelette #2* (2003; plates 35–37, pages 94–95), clothespins create a wide collar in the front and morph into a set of ribs in the back. They symbolically offer support, but also allude to the torturous whalebone corsets of the past. The materials are carefully chosen: clothespins and curlers have traditionally female associations, while glass taxidermy eyes protectively ward off evil.

Also endowing strength to the female wearer is *Fortitude* (2006; figs. 27–28, page 37). More armor than ornament, this work is constructed of flat sheets of brown mica that hold scrap metal and random coins. A surprise on the flip side honors Worden's paternal grandmother by embedding pages of her diary in segments of the necklace made of plastic and mica. The clasp, made from a broken oven thermometer, also salutes traditional female activities.

FIGURE 25. *Frozen Dreams,* 2004. Silver, nickel-plated copper, nickel coins, and acrylic, 20 (H) x 13 ½ (W) x 2 (D) inches. Collection of the artist.

Stories of forceful women fill Middle Eastern mythology. *Inanna's Laugh*, *Ereshkigal's Hook*, and *Brigandine for Ishtar* all refer to one of those ancient stories. One myth, told in many other cultures as well,

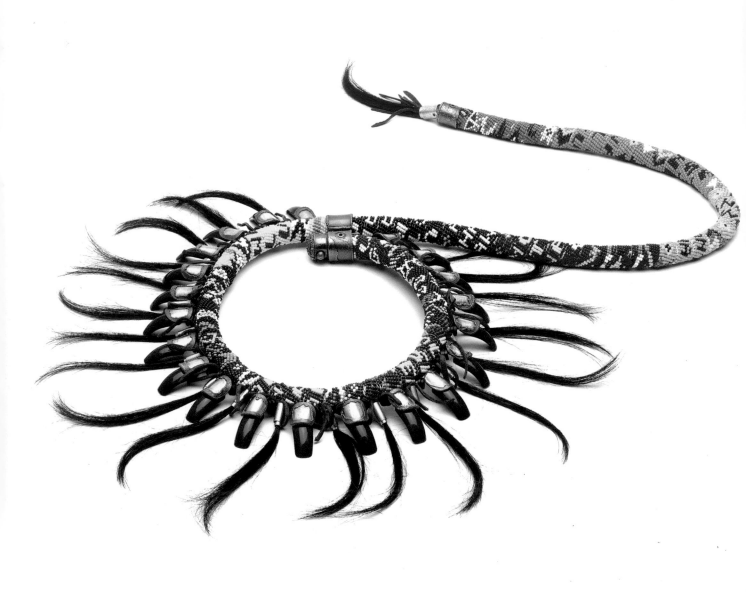

FIGURE 26. *Transfer of Power,* 2005. Silver, copper, glass
beads, glass eye, leather, artificial hair, and plastic,
27 (L) x 16 (W) x ¾ (D) inches. Collection of Tuan Lee.

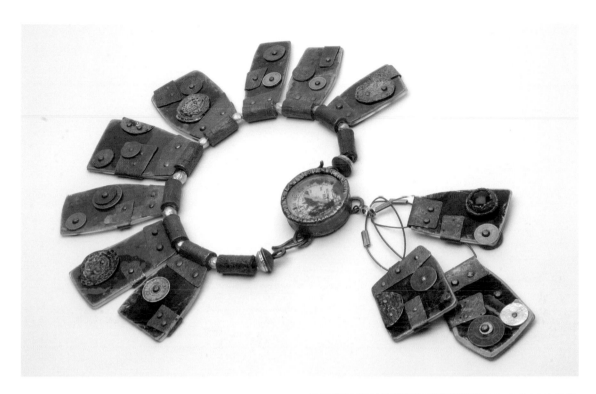

FIGURE 27 (above) and FIGURE 28 (right). *Fortitude,* 2006. Copper, silver, mica, steel, Lexan, paper, and glass; front: 20 (L) x 9 (W) x ¾ (D) inches; back: 7 (L) x 2 (W) x ¾ (D) inches. Collection of the artist.

describes a descent into the underworld, a near-death experience, and a return to the surface after compromising with the forces of darkness. Worden refers to the story of Inanna (or Ishtar), the goddess of fertility, sex, and war, and Ereshkigal, her older sister, the goddess of the underworld, death, and darkness. What particularly intrigued Worden was the role of jewelry in this story. First it empowers Inanna as she dresses to visit her sister in the underworld. Then, as Inanna descends into the underworld, she is required to remove the jewelry and her power disappears.

Ereshkigal's Hook (2004; fig. 41, page 57; plate 39, page 98) refers grimly to what

happened to Inanna at the bottom of the underworld. When she insisted, naked and disempowered as she was, on sitting on her sister's throne in the underworld, she was

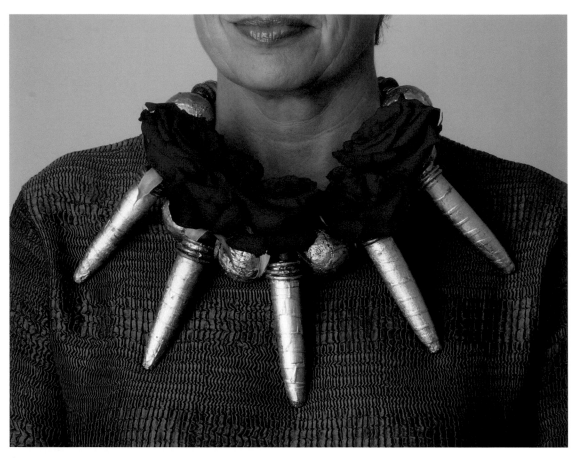

FIGURE 29. *Inanna's Laugh,* 2005. Silver, copper, 23K gold leaf, Pyrex, Styrofoam, and fresh roses, 24 ½ (H) x 9 (W) x 2 (D) inches. Collection of the artist.

condemned to become a piece of rotting meat hung on a hook.[14] This dark necklace is reptilian. Evil eyes look out from copper settings to form beads that hold electroformed chicken bones. Down the back are reptile-skin-covered cork "beads" with tacks pushed into them.

Inanna's Laugh (2005; fig. 29, page 38) has the opposite spirit, suggesting the blooming world when Inanna returns to the earth after her rescue. Celebratory and joyous, it is formed from gilded glass vials placed in cop-per electroformed settings. When it is worn, each vial holds a large red rose. Between the vials are oversized ball-like beads, making the vials seem like penis shapes. It is celebrating the power of women to make the world bloom, as well as the power of men to join in that positive endeavor.

On the same theme of mythic female power, *Brigandine for Ishtar* (2005; fig. 30, page 39; plates 44–45, pages 104–105) moves completely beyond the necklace to become a shield that covers the front and back. (A brig-

andine is a metal undershirt worn during medieval wars when soldiers were primarily on foot.) This work was inspired by the reports that the soldiers in the Iraq War were picking up scraps in the street to strengthen their Humvees. The brigandine is for Ishtar because she is the goddess of war and young women are fighting in Iraq. Worden's stunning work includes American copper pennies and nickels (both of which are worth more in metal than their face value today) as well as Japanese coins attached to a scrap-metal and mesh base that forms a haphazard layer of protection. Attached to the mesh base are also glass fish eyes electroformed into copper that watch out for the wearer. Weighted by tire weights that Worden picks up in the street, this formidable work is her most emphatic expansion into wearable art.

CONCLUSION

From her earliest jewelry made in Ellensburg, Washington, in the turbulent 1970s, to her present mature work forged in the midst of early twenty-first-century crisis, Nancy Worden has embedded her work in both her own life and the world in which she lives. Worden has been shaped by both the East Coast and the West Coast, by small-town academic life, rural farms, and large cities. As a middle-class white woman, she responds to personal challenges, honors history and myth, and takes on contemporary issues. The dramatic changes in her jewelry in format,

FIGURE 30. *Brigandine for Ishtar,* 2005. Copper, brass, nickel, steel, lead, and glass eyes, 21 (H) x 16 (W) x 1 ½ (D) inches. Collection of the artist.

scale, materials, and content follow the changes in her life and our society over the last thirty-five years. But above all, her jewelry reflects the time-honored purpose of body ornament that reaches back for centuries, to honor the individuals who wear it.

Worden's art is physical. We feel the weight on our bodies. Some materials are cold and smooth, others warm and rough. We fulfill its function by wearing it, but putting it on is never a casual act. The necklaces inhabit space, and they insist on good posture. The brooches require a proud, open chest. They are part of our body, rather than simply an ornament that we wear.

Wearing jewelry is predominantly a woman's act of declaring her identity: Worden's jewelry collaborates with the wearer in telling the world who she is, as she demands energy, pride, self-confidence, and even courage. If you don't have those strengths before you put on a piece of Nancy Worden's jewelry, you will when you are wearing it and hopefully, after you take it off.

NOTES

[1] Much of this essay draws on conversations with Nancy Worden on April 23, May 12, May 28, July 15, and July 31, 2008, with additional information in e-mails August 9 and 11, 2008.

[2] Characteristically for jewelry, this form has layers of history. Southwestern Native Americans learned silversmithing from the Spaniards. The Spaniards in turn borrowed it from the Moors, who made crescent-shaped bridle faceplates, called *najas*, to protect warriors and their horses from harm. The classic squash blossom necklace form combines the naja as the central pendant with side beads made to represent Spanish-Mexican pomegranates. Lois Sherr Dubin, *North American Indian Jewelry and Adornment: From Prehistory to the Present* (New York: Harry N. Abrams, 1999), 503.

[3] Vicki Halper's *Findings: The Jewelry of Ramona Solberg* (Seattle: University of Washington Press, 2001) is the primary source on Solberg's work. See also Regina Hackett, "Ramona Solberg, 1921–2005: The grandmother of Northwest found-art jewelry," *Seattle Post-Intelligencer,* June 16, 2005.

[4] Lee Nordness, *Objects: USA, Works by Artist-Craftsmen in Ceramic, Enamel, Glass, Metal, Plastic, Mosaic, Wood, and Fiber* (New York: Viking Press, 1970).

[5] Helen Williams Drutt English and Cindi Strauss, *Ornament as Art: Avant-Garde Jewelry from the Helen Williams Drutt Collection* (Houston: The Museum of Fine Arts, Houston, 2007).

[6] Worden comments about "Add-a-Beads": "[They] were an insipid idea that the jewelry industry created in the early eighties to sell gold beads. The idea was that you would buy one bead at a time and work up to a whole strand. I spent a lot of time when I worked in manufacturing replacing those ugly, cheap beads."

[7] According to Lois Sherr Dubin, "Evil eye ideology is complex. Different cultures interpret its effects in different ways, and remedies and preventative measures vary from one culture to another. . . . Eyes are often represented on amulets or painted onto buildings or tombs to counteract the evil eye. The protective eye can also take the form of beads. In many cultures, 'eye beads' are worn to deflect the evil eye or to neutralize its effects." *The History of Beads: From 30,000 B.C. to the Present* (New York: Harry N. Abrams, 2002), 307.

[8] According to Lois Sherr Dubin, "For Plains and Great Lakes warriors, matched bear claw necklaces were badges of courage. Obtaining the claws from a dangerous animal was considered an act of great bravery." *North American Indian Jewelry and Adornment: From Prehistory to the Present* (New York: Harry N. Abrams, 1999), 234.

[9] Susan Biskeborn, "Nancy Worden Getting Personal," *American Craft* (Oct/Nov 1998): 54–57, includes an excellent discussion of these Worden works. Biskeborn mentions that *Dead or Alive* also refers to Princess Diana, who was killed while being pursued by paparazzi as Worden was making the necklace. Diana's picture is set in the back of the camera lens.

[10] Worden electroforms on wax shapes painted with metallic paint. When the forming process is complete, she melts the wax out, leaving behind a thin hollow metal form.

[11] This was true when the baseball stadium was completed in Seattle in 1999 after taxpayers rejected bond issues for it, and it is still true today. See Peter Callaghan, "Taxpayers still on the hook at Safeco Field," *Tacoma (WA) News Tribune*, October 14, 2008.

[12] Quotations are from artist Ben Shahn, *The Shape of Content* (Cambridge, MA: Harvard University Press, 1957), as well as such people as mythologist Joseph Campbell, *Pathways to Bliss: Mythology and Personal Transformation* (Novato, CA: New World Library, 2004), 132–133; Roman poet Ovid, *Metamorphoses*, trans. Charles Martin (New York: W. W. Norton and Company, 2004), 169–171; and contemporary poet Billy Collins, *Sailing Alone Around the Room* (New York: Random House, 2002), 16.

[13] For an articulate essay on Nancy Worden's work, including this necklace in particular, see Matthew Kangas, "Nancy Worden—Excavations," *Metalsmith* 26, no. 1 (Spring 2006), 26–33.

[14] There are many variations of this story. This one is based on Dominique Collon, *The Queen of the Night* (London: British Museum Press, 2005), 42.

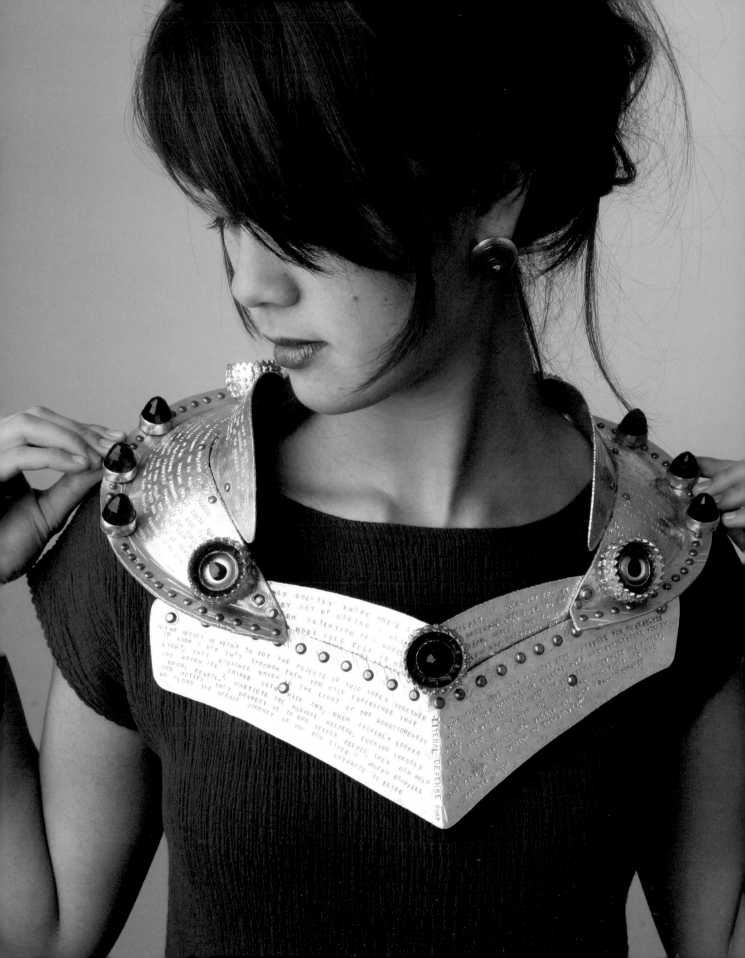

LOUD BONES
NANCY WORDEN'S JEWELRY

Michelle LeBaron

As a snake leaves
the map of her body on the hot sand path
so the marks of our troubles settle
finally
in our bones.

How to salve the painful tracks
when we cannot touch them?

Given voice, bones shout hope:
broken, they bond
bruised, they heal
buried, they nurture.

Beautiful bones, before you are dust
dance us on the serpents' path
never straight
temper our clashes with compassion
our edges to smooth gestures
our spines to undulating channels
where light and darkness mingle
as we find our way
whole.

—Michelle LeBaron

LIKE HER JEWELRY, Nancy Worden's exhibition title, *Loud Bones*, speaks on many levels.[1] It conveys her awareness of lineage and legacy; it challenges us to examine the "bones" of human relationships that form our families and communities. In shining light on bones, Worden asks us to look beyond image into structure, past surface levels and distortions to inner workings that shape outer forms.

For all that humans depend on them, bones are underappreciated and even denigrated. Common expressions—bonehead, bone tired, bone-dry, bare bones, bone-chilling, bone of

FIGURE 31. *Literal Defense,* 2007. Aluminum, silver, brass, copper, glass eyes, vintage glass, 23K gold leaf, plastic, and leather, 24 (H) x 13 (W) x 5 (D) inches. Collection of the artist.

contention—fail to acknowledge the strength, necessity, and resilience of bones. Rather, they conjure dry, spare, prone-to-brittle images of our inner structures. The expression "bone-head," for example, links bones to linearity that does not notice nuance and essential context.

Worden's work delivers context with bones, presenting them as the vital structures they are, giving them voices to call to us from the dark, fecund places in the body where instinct, intuition, and wisdom originate. These voices are necessarily loud, for they beckon from the sometime-somnambulism of our everyday existences—the places where routine can dull discernment, or where we become so inured to injustice or subjugation that we are resigned, our sensibilities muted and spirits dampened. Worden's work insistently calls us to step back from the noise of everyday dreaming to listen to what we know in our bones.

What *do* our bones know? Do we feel anger in our marrow when people are dismissed or diminished due to gender, socioeconomic class, or skin color? Do gaps between men and women in salaries, social freedoms, and role expectations make us sit a little less comfortably in our evening chairs or compel us to get up and *do* something to foment change? Nancy Worden's bones are irrepressibly restless, needing to name and shed light on conflict through her personal language of symbols and aesthetics. Her work speaks to women and is worn by women, baring social calcifications that may seem normal, but actually perpetuate injustice. While her primary audience is female, the message carried by the work is universal and compelling for men and women.

The themes of Nancy Worden's work relate to the heroine's journey through conflict and change: *questing, testing, wresting meaning, shifting, bridging,* and *integrating learning.* I have traversed this journey for twenty-five years as a scholar, author, and practitioner of conflict transformation—working with families, communities, and leaders to find ways through difficult conflicts. Beginning as an attorney, I found my vocation in helping others imagine ways out of knots and tangles. As a professor of conflict studies, I have come to see that over-reliance on scientific and analytic approaches leaves us bereft and our conflicts unresolved. In the midst of conflict, we need experiences that bring us in touch with heart, imagination, and beauty. Imagination shifts our focus away from limitations, liberating our capacities to envision peace and set old enmities aside.[2] Many times, I have witnessed people in conflict shift from destructive trajectories when a new metaphor inspired creativity or an image from art or nature opened a new channel of perception. Because change in conflict is powerfully catalyzed through the visceral experiences and embodied wisdom inspired by art, I begin with a description of how wearing Worden's neckpiece *Literal Defense* (2007; fig. 31, page 42; plate 48, page 109) reinforced my sense of vocation.

I lift it up carefully, aware of its intricacy and substance. The opening is just large enough for my curl-covered crown to wiggle through. Now its weight is balanced on my collarbones, its prow shape projecting forcefully forward, its scales dropping deliberately down my back. I sink to the nearest seat, noticing its impact. With *Literal Defense* on my frame, my verte-

brae align, falling into place as though suspended from a plumb line. I feel the work speaking directly to me, confirming my vocation to cut through pretense and fear as a conflict resolver. This responsibility—like the jewelry—feels weighty and insistent. Wearing it, I am changed. The neckpiece feels like a protective talisman, an ice-cutter for journeys to worlds of frozen, stuck dynamics.

Literal Defense, like much of Nancy Worden's jewelry, speaks to cutting through conflict with fortitude and courage. It is part of a three-decade suite of work that fits with Worden's strong presence like a glove. To be around her is to absorb a fierce commitment to counter fear and an indefatigable spirit of dynamic engagement. It is to question at every turn forces that would silence or subdue women. The fridge in her studio clasps a lone magnet to its chest proclaiming advice that Worden has passionately followed: "Don't ask permission."

Worden's work speaks loudly, not pausing to ask permission to address a wide range of conflicts, from interpersonal and marital to community and national. Her jewelry is designed to be worn, to be lent vitality by its wearers; in turn, it returns vibrancy to its subjects. It is hard to imagine wearing one of Worden's works and melting into the wallpaper—they stand out, shouting their messages in an original, iconic, and exquisitely crafted language that replaces representations of women as handmaidens with images of warriors, strong matriarchs, and intuitive, caring relations.

QUESTING: WOMEN'S VOICES AMPLIFIED

Worden's vocation was strikingly clear from an early age. She recalls that she was always making things, and this habit grew into a *need* to create that demanded fidelity. While there are many heroic female figures in history from whom she might derive inspiration—Florence Nightingale, Elizabeth Cady Stanton, Joan of Arc—Worden draws on heroic figures in ordinary lives: family matriarchs, caring friends, women who reject the maxim "Go along to get along" in favor of naming and engaging things that need improvement.

The bones of Worden's work are women's strong arms: reaching toward others, salving and transforming conflict, carrying truth. These arms can punch or push when needed; still they embrace the viewer with beauty and nurturing. Worden grafts imaginative possibilities onto individual and collective archetypes—those essential themes that populate myths and often re-create themselves in the lives of contemporary women.

To step into Worden's studio is to enter a world where the prosaic sisters the powerful. She employs articles that once populated women's everyday worlds: curlers, clothespins, corks, combs, cookie sheets. Her work hearkens back to simpler times before the speed and seduction of modern life carried us headlong into fragmented families too busy to share evening meals; before contemporary psychology left us confused about how to impose limits while giving our children unconditional love. Matriarchs, reminds Worden, were once unchallenged figures of power. Now, a woman who might have been a matriarch in an earlier

age—unequivocally strong, loving, and unchallenged in her realm—is labeled a "control freak." Thus, the bones of families crumble and the skeletons of young women are formed soft among mixed messages: be strong, but not too strong; set limits, but please others.

Why do we care? Worden's work loudly demands that we care. It insists that we look beyond our grandmothers' times to see the tracings of myths in our midst, the heroic journeys we are not taking, the role of nurturing families' spiritual welfare largely unfilled in too many American homes. The urgency comes upon us like the dawn—gradually breaking in ways that illuminate conscience, interconnectedness, and calling.

I will not soon forget the loud call I felt when wearing *Literal Defense*. With the metal pressed near my skin, my attention turned inward. I felt an impulse to hide, to shrink from the mantle of responsibility the neckpiece evoked. But I could not—it was difficult to remove, and it remonstrated me with its physical weight and twin calls to vision and voice emanating from its amulets of eyes and typewriter-ball letters. I was reminded that I have something to say to the world, and hiding is not an option.

I wonder what would happen to other women wearing this neckpiece. What could they experience as they bear its decisive weight? Which calls might it communicate to them as a medium for their inner promptings? Which ice would melt in its wake—frozen artifacts of stuck conflicts finally seen for the thaws that are possible?

Looking closer at *Literal Defense*, I read the inscriptions. Worden quotes Joseph Campbell: "Artists are magical helpers. Evoking symbols and motifs that connect us to our deeper selves, they can help us along the heroic journey of our own lives."[3] Her neckpiece had indeed helped, giving me clarity and reassurance on my quest for vision and voice. Other quotes on *Literal Defense* range from Ovid's *Metamorphoses* to the poet Billy Collins, the writer Shakti Gawain, and the painter Ben Shahn. Worden casts her net widely, collaging words with found objects in provocative ways.

Taken together, Worden's body of work fulfills her quest—to help people recognize, name, and respond to cracks in individual lives and social fissures with compassion.[4] She embraces the leadership role her brilliance confers, understanding and magnifying its potential, inspiring caring to convert the negativity that so often accompanies conflict into constructive action.

TESTS AND TRIALS: OVERCOMING OBSTACLES IN CONFLICT

Worden's alchemy transforms the dross of personal conflicts into art. One of her early works, *Marital Bliss* (1980; fig. 32, page 47), speaks to conflict in her first, short-lived marriage. In the filigree-wire drawing, she and her husband, an engineer, are in bed with thought bubbles coming out of their heads. Her husband sprouts thoughts in organized spirals; above her is a mass of interconnected, apparently disorganized squiggles.

As Worden's work makes plain, the tests of conflict arise not only from actions; they also come from differences in who we dream ourselves to be and how we pay attention. The radically dissimilar thought bubbles telegraph

FIGURE 32. *Marital Bliss* (in progress), 1980. Copper and silver, 4 ¾ (H) x 6 (W) x ¹/₁₆ (D) inches. Collection of the artist.

different cognitive habits and ways of relating to the world. When someone with organized spirals tries to collaborate with someone with a mass of squiggles, conflict is likely. While each may be frustrated with the other, often the approach of the dominant group (in this case professional male culture) prevails. The less linear approach—in this case, the woman's—may be labeled deviant, disorganized, or in need of "fixing." When both people respect each other's ways of knowing and expand their vision to accord each other legitimacy, conflicts like this can be successfully managed.

Worden's *Middle-Aged Mom* series continues the theme of gender-based conflict. It features women engaging real tests over prosaic, yet symbolically important issues. *Bathroom Bowl Blues* (1992; fig. 33, page 48; plate 5, page 68), for example, memorializes Worden's conflict with her longtime second husband over who would clean the bathroom. Here, a toilet brush is set amidst precious gems in a brooch that will stir recognition from anyone who has ever been in conflict about chores and division of work. It also evokes humor, as the elements of the composition are identified.

Another work that combines humor with social insight is *Nights in Shining Armor* (1994; fig. 34, page 48). It juxtaposes a Trojan warrior complete with hematite balls and a penis-

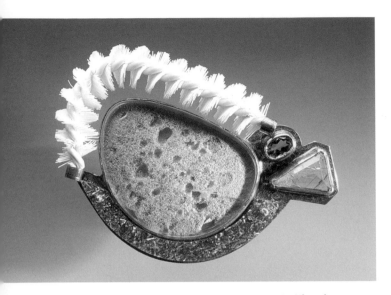

FIGURE 33. *Bathroom Bowl Blues,* 1992. Silver, brass, tourmaline, rutilated quartz, eyeglass lens, sponge, wire, and bristle scrub brush, 2 ⅛ (H) x 3 ¼ (W) x ½ (D) inches. Racine Art Museum, Gift of the artist.

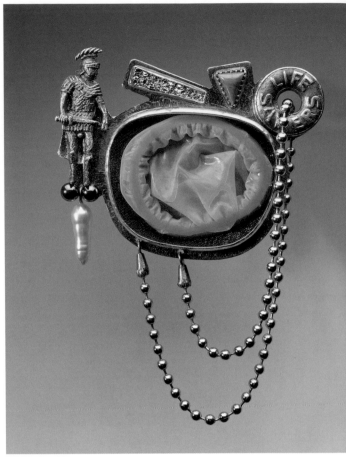

FIGURE 34. *Nights in Shining Armor,* 1994. Silver, pearl, rhodonite, pyrite, steel ball chain, and condom, 4 (H) x 3 (W) x ½ (D) inches. Collection of Martyl Reinsdorf.

shaped pearl opposite a replica of a lifesaver. The lifesaver is a powerful female symbol, evoking receptivity, survival, and sweetness. In the middle of the brooch, unmistakably, is a condom. *Nights in Shining Armor* expresses Worden's awareness that fairy-tale heroes rescuing vulnerable damsels create unrealistic expectations for both women and men. After all, men are not superheroes and they cannot read women's minds about whether, when, or how help is needed. When women step out of fairy-tale fantasies, they can summon the strength to navigate challenges. Like all of Worden's jewelry, this one has a real-world function; it helps her—and other women—get perspective on their roles and choices in conflict. The humor embedded in the work helps viewers realize just how unrealistic and crippling traditional sex-role expectations can be. Works like *Nights in Shining Armor* double as beautiful object lessons: she reports telling young women in her audiences not to expect to find knights in shining armor; it is more realistic to hope for "a nice guy who wears a condom."

WRESTING MEANING FROM CONFLICT: USING SYMBOLS, STORIES, AND RITUALS

While conflict is an agent of social change, it is not always obvious how to harness or engage it. Sometimes, our best efforts result in conditions worsening rather than improving. People

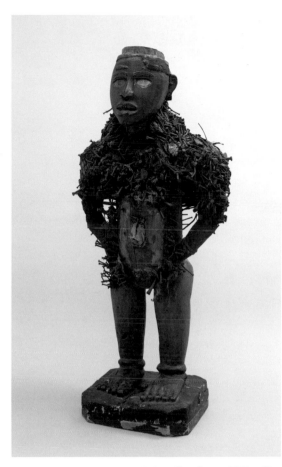

FIGURE 35. CONGOLESE KONGO. Standing figure (N'Kondi). Wood, iron, fiber, beads, string, glass, feathers, and chalk, 31 11/16 (H) x 13 3/8 (W) x 8 11/16 (D) inches. Seattle Art Museum, Gift of Katherine White and the Boeing Company, 81.17.836.

meaningful social rituals can be difficult to find. Many communities no longer have acknowledged elders to whom to take grievances. Large numbers of people are estranged from institutions like churches and governments and disillusioned about opportunities for meaningful social involvement.

Worden addresses the lack of social rituals and figures for engaging conflict in one of her most striking and iconic works, the *N'Kondi Collar* (2008; fig. 36, page 49). Unlike most of

are often confused about when to confront and when to be indirect; they flounder when venturing into the terrain of threatened identities and strong emotions. One of the keys to addressing the tests inherent in conflict, especially if it has been going on for a good while, is social ritual. Rituals help people transition; they offer a route through contested terrain that can smooth and mark progress, while easing the pain of loss. In contemporary American society,

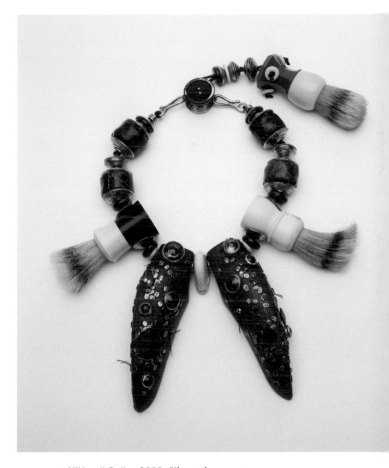

FIGURE 36. *N'Kondi Collar,* 2008. Silver, glass eyes, celluloid, horn, bone, plastic, alligator skins, brass, steel, cotton cord, and badger bristle, 21 (L) x 6 (W) x 1 ½ (D) inches. Collection of the artist.

her work, which is made of objects traditionally associated with women, it features shaving brushes, pieces of a man's shoe tree, and skin from an alligator wallet. Its inspiration comes from the male figures made of sacred wood by the Kongo people to promote healing and cooperation (fig. 35, page 49). Nails were driven into traditional N'Kondi figures to mark solutions to conflict, channeling negative energy into the wood and freeing the people involved to get on with their lives. Worden's *N'Kondi* is a wearable scion onto which to graft conflicts, making concrete what might otherwise be carried as free-form anxiety and diffuse unease. The ritual of wearing the collar that features space for adding new nails underlines the importance of marking breakthroughs and consciously channeling the negative energy that often accompanies conflict.

Worden's work *Shackles of Fear: Fear of Change* (2007; fig. 37, page 51) confronts the sternum of conflict: fear. Two bracelets are joined by a large chain made of copper and silver. The bracelets are so beautifully crafted that I immediately want to wear them. Only as I put them on, feeling the weight of the python-encrusted, unzipped silver and their associated chain, do I *feel* their message: fear grows in us as we avoid confronting those things that need to shift, trapping us in heaviness from which it appears hard to move. I feel a strong need to remove the bracelets almost immediately after they are fastened. I feel the pendulum inside me, one part moving toward conflict with resolve and clarity, the other shrinking back into the known, familiar world, content to "take a little rest."

Yet I feel trapped, believing that I cannot remove the bracelets without help. At regular intervals along the chain, glass eyes watch me reproachfully, asking "What have you done today about the ways your limiting beliefs keep you stuck?"

Only after several long minutes do I realize that the bracelets hold the key to shedding self-imposed limits. They actually come off with relative ease: it just requires a shift in perception.

I have a flash of an idea: what if people in conflict each participated in a ritual of wearing the shackles? Could they then come together, share stories of their experiences, and engage collaborative questions like what we can do to address those things that keep us weighted down, unable to reach to and beyond the solutions to our problems. I sense that the physical experience of wearing the bracelets would generate dialogue to shift the focus from the other as adversary, directing attention instead to ways each are limited and how they might be able to assist each other to lift or relax limitations.

M. C. Richards (1916–1999), a famous American potter and author, tells us that the way through conflict is like the serpent's path: never a straight line.[5] Nancy Worden's work amplifies this insight; observing, touching, and meditating on her jewelry offers a multilayered, tactile experience of emotional, aesthetic, and creative capacities to meet the twists and turns in conflict. Each work is animated by a story and evokes stories from wearers and viewers. Storytelling is an important ritual to help shift conflict; even when positions are opposed,

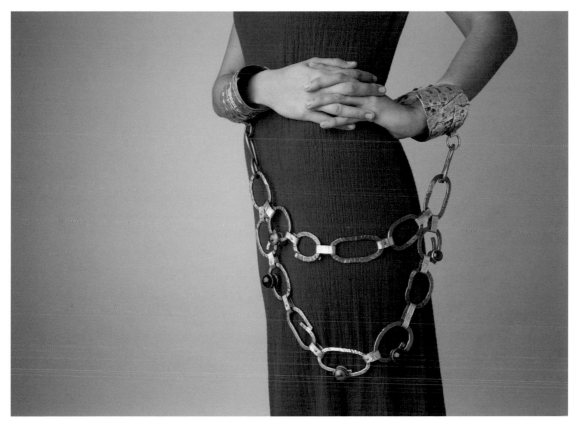

FIGURE 37. *Shackles of Fear: Fear of Change,* 2007. Silver, copper, python skin, zipper, shoelace, and glass eyes; zipper bracelet: 3 ⅝ (H) x 2 ¾ (W) x ½ (D) inches; laced bracelet: 3 ½ (H) x 2 ¾ (W) x ½ (D) inches; chain: 32 (L) x 6 (W) x 1 ¼ (D) inches. Collection of the artist.

hearing each other's stories builds empathy and understanding.

We literally shape our reality depending on the stories we tell about ourselves and others. Are we victim or heroine; do we see endless riches or scarcity? How many layers have we and others created, confining our vision and perceived options? Often, when trapped in conflict, we perceive limited choices. We may be surprised to find that new possibilities arise as we look out from the corners in which we have felt trapped.

But we do not easily turn away from corners. As conflict insinuates itself into our identities and precious meanings, it becomes more entrenched. We need to feel secure and protected before taking the risk to turn from the known; we need resources as we venture into untested, uneven terrain. Sometimes, we need help to put the issues in conflict onto a bigger grid. Empathic friends and leaders who understand that personal and political dimensions of conflict are intertwined can help us shift perspectives.

An example comes from the ground - breaking peace agreement at Camp David facilitated between Prime Minister Begin of Israel and President Sadat of Egypt by U.S. President

Jimmy Carter in 1978. In preparation for the negotiations, Carter spent many hours studying the leaders' personalities. During the process, he observed that Begin and Sadat clashed frequently, so Carter initiated shuttle diplomacy as a way of smoothing relations between them. As the negotiations bent to near breaking under the weight of bad feelings and years of enmity, Carter tried one last strategy. He visited each leader in his quarters, changing from casual clothes into a suit before presenting President Sadat with a photograph of the three of them, inscribed personally to his grandchildren. Carter took an identical photo to Prime Minister Begin. The photos were catalysts for restarting the ultimately successful negotiations, evoking as they did multigenerational legacies and the larger context, including the urgent need to limit loss and find ways for each nation to look beyond the moment.

This account is particularly relevant to Worden's jewelry. Her work demonstrates deft sensitivity to the intermingled personal and political threads of conflict. She is acutely aware of the effect of context on communication, especially as context is influenced by dress. Worden recognizes and reminds us that small or incremental changes can and do catalyze larger shifts. Her work speaks in layers, revealing deeper dimensions as it is contemplated over time.

In conflict, we constantly confront interconnected layers. Even as we seek peace, we may feel anger and a desire for revenge. When we find a quick fix, we may be surprised that later another issue surfaces from deeper terrain where time has not healed, but festered, old

hurts. We are challenged to find a place to stand, to touch the sense of security we need to engage flexibility and change. One of Worden's most beguiling works speaks to achieving this security amidst interconnected layers of conflict. *Brigandine for Ishtar* (2005; fig. 30, page 39; plates 44–45, pages 104–105) is a rich, multilayered breastplate that begins as a collar and extends down the back to cover heart and lungs. When she started making it, Worden was thinking of how humans gain layers like rings on a tree as we age. Maturing, we become more ourselves and increasingly manifest what we have given our lives to. If we have focused on fear, we embody anxiety. If we have given ourselves to compassion, we exude kindness. If we have successfully transited the challenges of our lives—conflicts, tragedies, disappointments—we come home to ourselves with appreciation for the journey, exquisitely aware of its complexity, paradox, and pathos.

This sense of coming home is what I felt when I first saw *Brigandine for Ishtar*. Putting it on, I feel immediately comfortable. The work sits heavy on my frame, but in a dignified, aesthetically arresting way. I love the richness of the copper and the juxtaposed textures of the coins, metals, and fabrics. I feel myself in a waking dream in which beauty attends me, where everything needed to support the ongoing vitality of my heart is provided. *Brigandine* features the comfort of familiar fastening buttons, the resource of coins, the beauty of burnished metal, and—not surprisingly—eyes to extend the limits of my vision.

Like many of Worden's works, this one has multiple levels. As she made *Brigandine for*

Ishtar, it evolved into an unabashed offering of armor, succor for the first generation of young women going off to war, the offspring of Worden's contemporaries. As I wore it, my thoughts went to women warriors in history, especially Joan of Arc and the undershirt of armor she wore as she led the French army to victory in the Loire Valley. Joan of Arc is still remembered for meeting her mission with single-mindedness and courage. I wondered what our world would be like if women learned that kind of courage in today's schools. What if young girls were given a mantle like *Brigandine for Ishtar*, taught about female heroes, and encouraged to hear their own calls to leadership? Surely the ritual and ceremony of wearing such a work—and mindfully creating their own armor—would inspire courage in memorable ways.

Wearing jewelry for ceremonial and symbolic purposes is as old as human history. Using jewelry as a way of inviting reflection and seeing conflict is a newer phenomenon, pioneered by Nancy Worden. Many of her works are encrusted with eyes and ears, reminding the wearer or viewer to listen deeply and observe carefully. Worden reports donning her necklace *Beans in Your Ears* (1996; fig. 1, page 6; plate 17, page 75) when attending public meetings as a way of bodily emphasizing the importance of listening. Fellow attendees get the point—and can take it in—as the necklace evokes appreciation for the beauty of the different colored ears with their lapis bead impediments to hearing. *Lend Me Your Ears* (1993; fig. 38, page 53) and *Grafting* (2001; fig. 42, page 58; plates 30–31, page 90) amplify this theme; the latter

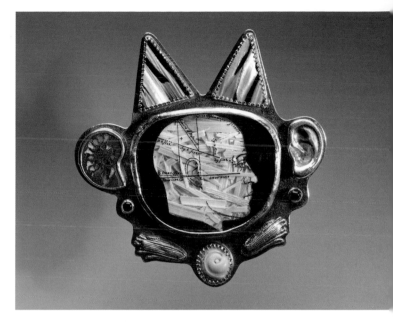

FIGURE 38. *Lend Me Your Ears,* 1993. Silver, plastic, straw, paper, shell, glass, citrine, and pyritized ammonite, 3 ¼ (H) x 3 ¼ (W) x ¼ (D) inches. The Daphne Farago Collection, Collection of Museum of Fine Arts, Boston.

necklace features 14 karat gold ears, underlining the value of listening. These works also invite lightness; humor is a key tool in conflict when we might otherwise sink into the heaviness of despair.

Effective communication—listening and speaking stories clearly—is at the very heart of constructively addressing conflict. Conflicts escalate when people hoard information, equating it with power. Worden's brooch *Mixed Messages* (1993; fig. 39, page 54; plate 9, page 71) speaks to the importance of congruence between speech and action. She made it after an experience with a "people pleaser" who would appear to agree, but not follow through in action. The work is a collage of yin/yang images for yes and no, with candy hearts in its center inscribed with the words

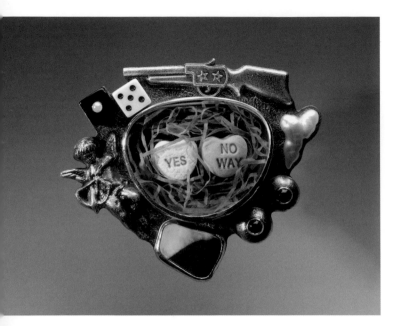

FIGURE 39. *Mixed Messages,* 1993. Silver, onyx, pearls, pebble, glass, plastic, paper grass, and candy, 2 ½ (H) x 3 ¼ (W) x ½ (D) inches. SM's - Stedelijk Museum 's-Hertogenbosch / NL.

"yes" and "no way," as if to offer the pleaser a sweet, clear choice of response.

Also directed to communication in conflict is *Hidden Agenda* (1994; fig. 18, page 26; plate 12, page 72), a brooch about an estate dispute. In this instance, Worden confronted a friend on the subterfuge being used in the conflict. When the friend broke off the relationship, Worden made an alchemical choice to focus on her own healing and made a work of art about it. This is one of several works in which Worden is a participant in the subject of her work, engaging with conflicts and themes that implicate her as well as a wider circle of viewers and wearers.

TRANSITING THE UNDERWORLD: SHIFTS HAPPEN
When conflict happens, it takes us on a journey. We do not necessarily know when or how or if

it will resolve, and anxiety attends that uncertainty. The liminality, or feeling of in-betweenness, of conflict may make it harder to solve: when we are tight and defended, our access to creativity is limited. When the "givens" of our lives are no longer reliable, we break open, needing to change. Worden's conversance with myth is a great boon to women in the midst of conflict or major change. She draws on Joseph Campbell who advised that when the mask we are wearing cracks, we must ask what is alive for us in the present and what will activate the world we are in. In a low or conflicted time, it may be difficult to access the creativity needed to find a new response. Much of Worden's work suggests paths and symbols that can help, ultimately leading to a shift.

It is not only individuals who need to find ways to dance with vitality when the old ways stop working. Societies, too, need to find new ways to proceed, antidotes to what Campbell calls the "terminal moraine of broken mythological traditions."[6] Worden's jewelry helps on both societal and individual levels.

In times of stress, it is not easy to identify new ways to proceed. The events of September 11, 2001, for example, challenged many Americans deeply. Her neckpiece *Vicious Circus* (2002; plate 32, page 91) addresses the hate she heard shortly after those tragic events and her awareness of how calls for revenge escalated violence. The mouths on the neckpiece yield protruding serpents' tongues; in this case, the serpent symbolizes not transformation but venom.

Casting Pearls before Swine (1997; fig. 40, page 55; plate 20, page 78) also treats the sub-

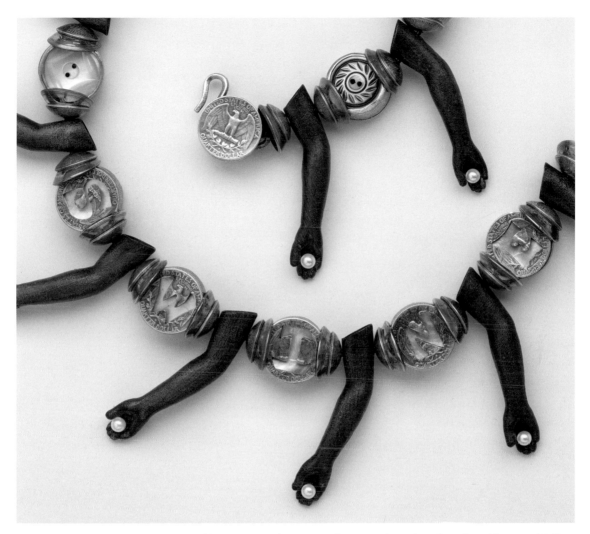

FIGURE 40. *Casting Pearls before Swine* (detail), 1997. Silver, copper, brass, pearls, and mother-of-pearl buttons, 23 ½ (L) x 3 (W) x 1 (D) inches. Collection of Susan Beech.

ject of shifts or turning points. It references a project in which Worden was involved where a colleague treated her in rude and disrespectful ways. Rather than jeopardize the project, she maintained a professional countenance, taking out her rage in this intricately made necklace where a series of small copper hands hold pearls. Flat lettered beads made from silver quarters are interspersed among the hands; they spell "SWINE" in mother-of-pearl. The work speaks to choosing whether and how to confront a counterpart in a conflict, suggesting that there are times when the best course is to get the task done and find a way to shift internally rather than attempt a direct interpersonal resolution. It also speaks to graciousness; Worden's choice to channel her frustration into a creative project rather than match her colleague's tac-

tics—which she certainly could have done—is a powerful model of a healthy choice. Rather than bottle up feelings, she expressed them in ways that gave her relief and graced viewers of her work with inspiration.

Other sources of inspiration for Worden are the myths she uncovers when trolling for material that speaks to women's experiences and challenges. A striking example is *Ereshkigal's Hook* (2004; fig. 41, page 57; plate 39, page 98), which speaks to shifting conflict dynamics, albeit in an extreme way. It is based on a Sumerian myth in which Ereshkigal slays her sister Inanna's lover, thus banishing him to the underworld. Inanna, enraged, goes to the underworld to get him back. Stripped of her jewelry as she descends, Inanna is no longer powerful and is slain by Ereshkigal, her body hung on a hook. Jungian writers interpret this myth as speaking to the capacity for evil in all women. *Ereshkigal's Hook* evokes the words of M. C. Richards, who asks, "Can we imagine a kind of peace that includes the freedom to conflict, a kind of warmth that includes the freedom to withdraw, a kind of union that asks for free and unique individualities, a kind of good that grants the mystery of evil, a kind of life that bears death within it like a seed-force?"[7] Worden's work offers a way to contemplate these unions of opposites and to comfort women in their descents into dark places as they encounter their own and others' capacities for destruction. In the end, she offers hope: Inanna does revive and return from the underworld through the efforts of Ninsubur, a loyal minister. *Ereshkigal's Hook* is a powerful reminder of our capacity to return from tragedy—whether born of death or destructive conflict—and thrive again. This is the ultimate shift.

RAPPROCHEMENT IN THE RAPIDS: BUILDING DURABLE BRIDGES ACROSS DIFFERENCES

Once a shift in conflict has occurred, a space may be opened for problem-solving and new ways forward. This is powerfully addressed in *Conjugal Bushwhacking* (2000; plate 27, page 87), a necklace made of lava beads chosen deliberately to irritate the neck of the wearer. The work arose from Worden's experience of hacking stinging nettles with a machete on a piece of mountain property with her husband. As they were working, she realized that their struggle with the nettles was a metaphor for what they had been going through in their relationship. In a long marriage, she explains, you have to hack out the weeds and deadwood to allow new growth. Relationships need hard work, patience, and trust that something new will grow once the nettles have been cleared.

Growing something new in the aftermath of struggle requires creativity and tenacity. Worden's neckpiece *Grafting* (2001; fig. 42, page 58; plates 30–31, page 90) shows a way forward—just as the apple farmers she knew during childhood grafted disease-resistant trees together to yield stronger varieties—the work evokes our limitless capacity for learning. The original impetus for *Grafting* came from Worden's frustration with hearing the excuse "That's just the way I was raised" to justify

FIGURE 41. *Ereshkigal's Hook,* 2004. Silver, electroformed copper, brass, steel, cork, reptile skin, cotton cord, and glass eyes, 30 (H) x 1 ¾ (W) x 1 ⅜ (D) inches. Collection of Marion Fulk.

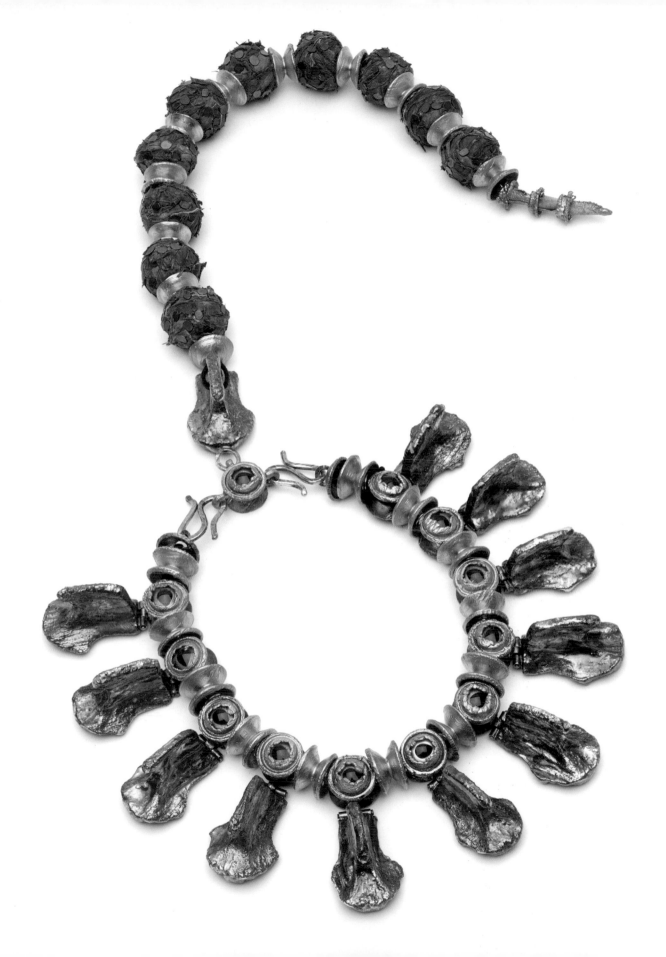

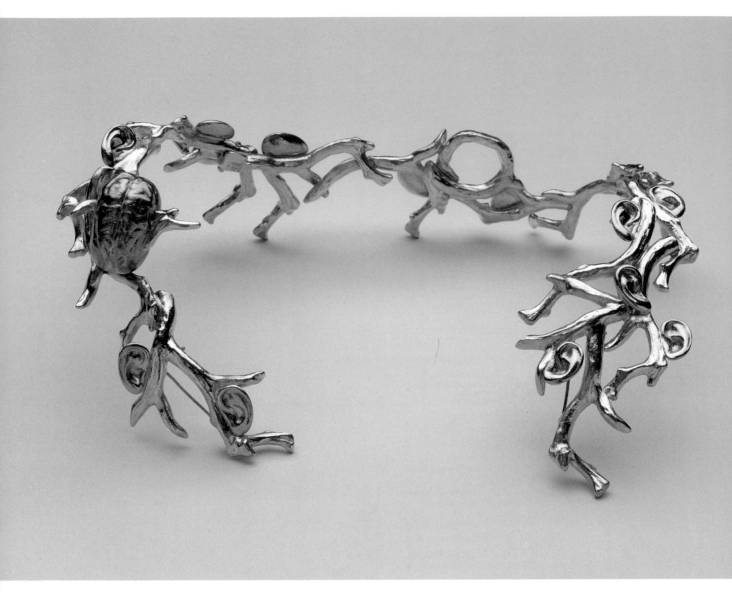

FIGURE 42. *Grafting,* 2001. 14K gold, silver, and gold-plated copper, 24 (L) x 2 ½ (W) x 1 ½ (D) inches. Collection of the Boardman Family.

conflict-escalating behavior. One of Worden's most beautiful creations, *Grafting* features 14 karat gold ears that are all attached to a tiny brain, concretizing the importance of continually expanding our attention and awareness.

Taken together, *Conjugal Bushwhacking* and *Grafting* suggest reliable ways forward after conflict: clear away the residue, work from your strengths, take responsibility for your own behavior, and maintain a spirit of openness and inquiry.

FULL CIRCLE: INTEGRATING LEARNING FROM CONFLICT

Resolving conflict does not necessarily mean it is transformed. Sometimes, an issue is addressed only to find that other differences surface later. When there is a history of enmity, salving conflict can take time and patience as layers of hurt are peeled away and tender shoots of connection are nurtured. *Gilding the Past* (2001; fig. 43, page 59; plates 28–29, pages 88–89) speaks to conflicts in which strategies are borrowed from another time and place but suffer from a lack of fit or congruent purpose. Worden was stirred into creation by the World Trade Organization riots that took place in Seattle in 1999. While many in anarchist and radical circles may have termed the Seattle riots, protests, and demonstrations a success, Worden felt that the protesters had romanticized the causes of earlier decades and

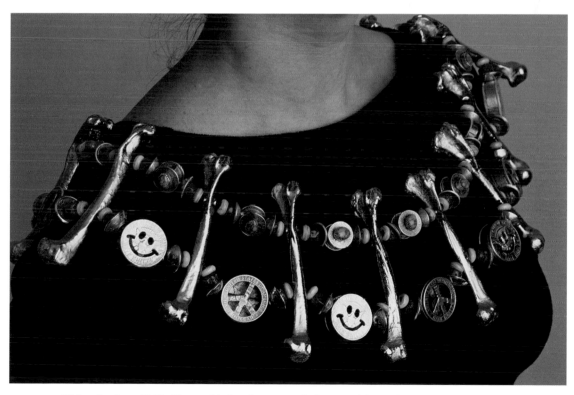

FIGURE 43. *Gilding the Past,* 2001. Silver, gold-plated copper and silver, coral, brass, bone, cotton cord, and turquoise, 43 (L) x 4 ½ (W) x ¾ (D) inches. Collection of the Boardman Family.

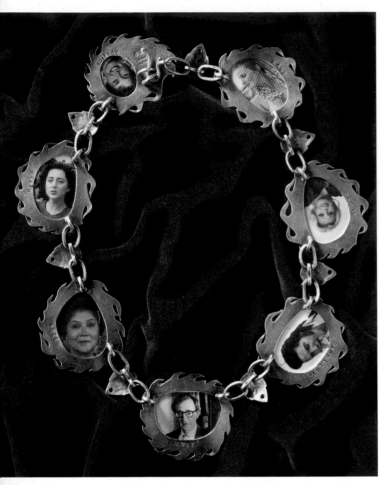

FIGURE 44 (above, back) and FIGURE 45 (right, detail of front). *The Seven Deadly Sins,* 1994. Silver, synthetic rubies, glass, plastic, steel, candy wrappers, broken mirror, brass, and laminated photographs, 20 ½ (L) x 2 (W) x ½ (D) inches. Museum of Arts & Design, New York, Gift of the artist and the William Traver Gallery, 1995.

escalated into violence too quickly, upstaging the other, nonviolent protesters and showing lack of respect for local business owners and their property. *Gilding the Past* is a symmetrical necklace, appropriately made from gold-plated Kennedy half-dollars pierced with smiley faces and interspersed peace signs. The back of the beads spell the words "Good Old Days." The

backbone of the necklace features big, gold-plated bones; if they had a voice, they would surely advise temperance and dialogue before direct violent action.

From the large-scale impact of the "Battle in Seattle" to the small-scale, but equally important, conflicts of people's home lives, the eyes, ears, and bones of Worden's work take an interest in what surrounds them. A personal work, *The Seven Deadly Sins* (1994; figs. 44–45, pages 60–61; plate 13, page 73), speaks to her experience of watching a neighbor build an addition on her home that replaced the view Worden and her family had of the mountains and a lake with a view of a new wall. Silver devils punctuate a necklace of eyeglass lenses filled with found objects representing lust, wrath, envy, greed, and the other capital vices. Significantly, Worden did not stop with this creation. Showing the value she places on beauty and community relations, she replaced the wall-facing window in her home with stained glass made by another neighbor. The experience reinforced and memorialized Worden's awareness that we cannot control others, but we do have choices about how we respond.

The Seven Deadly Sins is an icon of transformation; it reminds us to change what we can and find ways to process our feelings about the rest. If we can find ways to see conflicts through a kaleidoscope rather than a tunnel and to replace ugliness with beauty, our futures as local and international neighbors will be brighter and more functional. If we can find ways to replace greed with dialogue, we will be truly transformed.

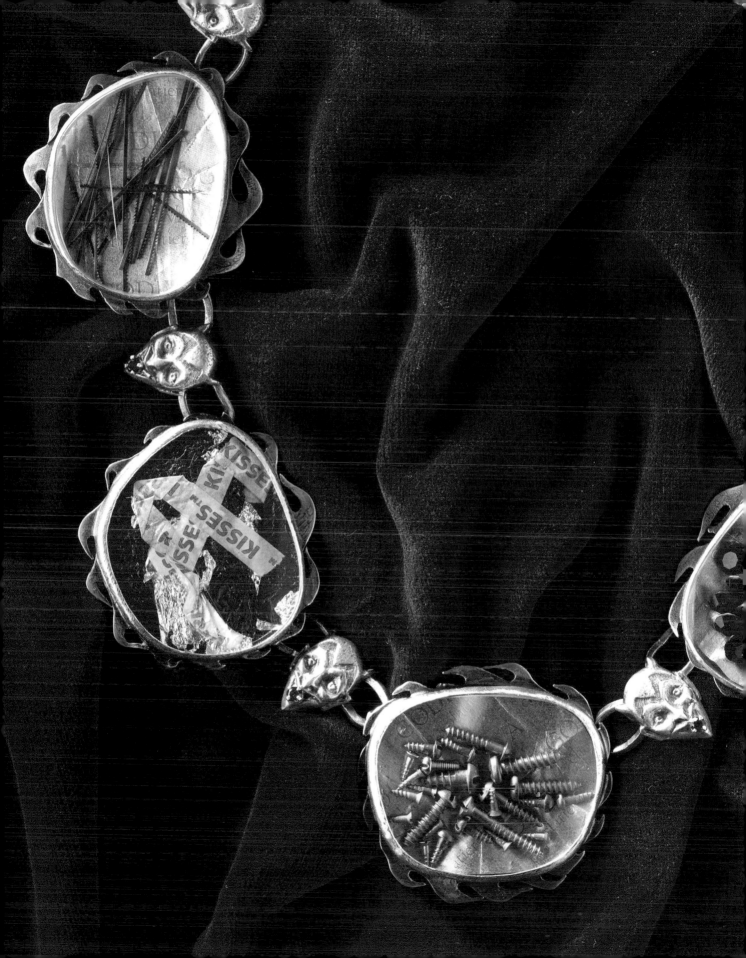

THE SERPENT'S PATH TO CONFLICT TRANSFORMATION

The ancient symbol of a serpent eating its tail—*ouroboros*—is evoked by much of Worden's work. It speaks to recognizing cycles that yield the possibility of transformation even in dark times. In the spirit of ouroboros, I asked Worden what her work has to say about conflict, change, and life in general. She spoke of being raised in a small community in pre-mall America, when people took the time to know local merchants, and neighbors helped each other with chores and childcare, when someone showed up with an apple pie when the chips were down. Worden described the goal of her work as emphasizing the beauty of everyday objects and offering comfort to women who recognize the challenges she addresses as their own. Through the alchemy of playful seriousness, Worden inspires us to breathe kindness and compassionate awareness of community into our relationships. Given the conflicting maps for contemporary women's roles, she provides amulets, armor, and anchors to protect from the noisy world that would take us from caring into the grabby clutches of greed and selfishness.

She muses: "We don't have to worry about saber-toothed tigers anymore. But we do have worries. It is hard to be a good parent, a good sibling, a good friend, a good partner or spouse. So many people can't talk about issues." And so she addresses issues in her own prescient language: tangible, kinetic, intuitive, and beautiful.

Hers is not a preachy body of work, but a searing one, unforgettable for its rich imagery and thoughtful compositions. Worden does not let us off lightly, taking her inspiration for melding confrontation and humor from talents like Louise Bourgeois (born 1911). She calls the bluff of those who would shrink from conflict or strong emotions, urging us to find constructive and creative ways to express ourselves, including our anger. She travels to the underworld for us—and back—a modern-day Ninsubur. She has befriended the face of conflict and gives us the jewelry that can make us strong as we wear it or imagine wearing it. When conflict arises, one of her works may come to mind, admonishing us in the unwavering voice of a strong, clear matriarch:

- Don't hide.
- Relate to what is.
- Don't be afraid.
- Be courageous.
- Be kind.
- Do unto others as *they* would have you do unto them. The Golden Rule is not always best.
- Be prickly; take your cue from nature. "Nice" plants don't always survive.
- Take up space.
- Claim voice. Talk loudly. Say what you feel.
- Care, but not at your own expense.
- Find balance.
- Fully inhabit your body. Tread with some weight—don't try to tiptoe past the hard bits.
- Listen. Even to the weak or the old-fashioned.
- Pay attention to how myths dance into being in your life; find guides for the underworld and the dark places so you

need not cower from what is yours to do, even—or especially—if it is unconventional or scary.

Worden's work is ultimately about making choices based on careful observation, especially self-observation. In this, she penetrates the most uncomfortable aspect of conflict: the necessity of looking in the mirror and examining collective and individual roles, motives, and trajectories. Worden acknowledges that this experience may be unpleasant: "Sometimes when you line up with yourself, you learn some things that aren't fun to know about you. It can be scary and uncomfortable." Still, this honesty is vitally important if we are to move from the archipelagos of fractured communities and families to the quickening of unity so needed in today's world.

Finding perspective and unity in a postmodern world is not easy. Yet, meeting challenges with spirit and imagination is far preferable to resignation and mass somnambulism. Imagine a theatre where all the players knew they would have a single performance—a chance to breathe life into stories that would be told once, ending in death. Life, in essence, is this. We are sometimes gifted with a taste of immortality in ecstatic art or music. But for most of us, most of the time, there are the daily tasks of housekeeping, driving, parenting, gardening, and relating to each other, tasks that are begging to be done with kindness and awareness. Life is a constantly pulsing series of changes to be met and navigated—sometimes with great fervor and other times with deft reverence. Nancy Worden, in a language that speaks to our very bones, does both.

NOTES

[1] Much of the information in this essay comes from conversations with Nancy Worden on May 5–6, July 26–27, and August 2, 2008, with additional information in e-mails exchanged May 1 through August 31, 2008.

[2] M. C. Richards, "Separating and Connecting: The Vessel and the Fire," in *The Fabric of the Future: Women Visionaries Illuminate the Path to Tomorrow*, ed. M. J. Ryan (Berkeley, CA: Conari Press, 1998), 245.

[3] Joseph Campbell, *Pathways to Bliss: Mythology and Personal Transformation* (Novato, CA: New World Library, 2004), 132.

[4] Ibid., 78.

[5] Richards, "Separating and Connecting," 244.

[6] Campbell, *Pathways to Bliss*, 100.

[7] Richards, "Separating and Connecting," 234.

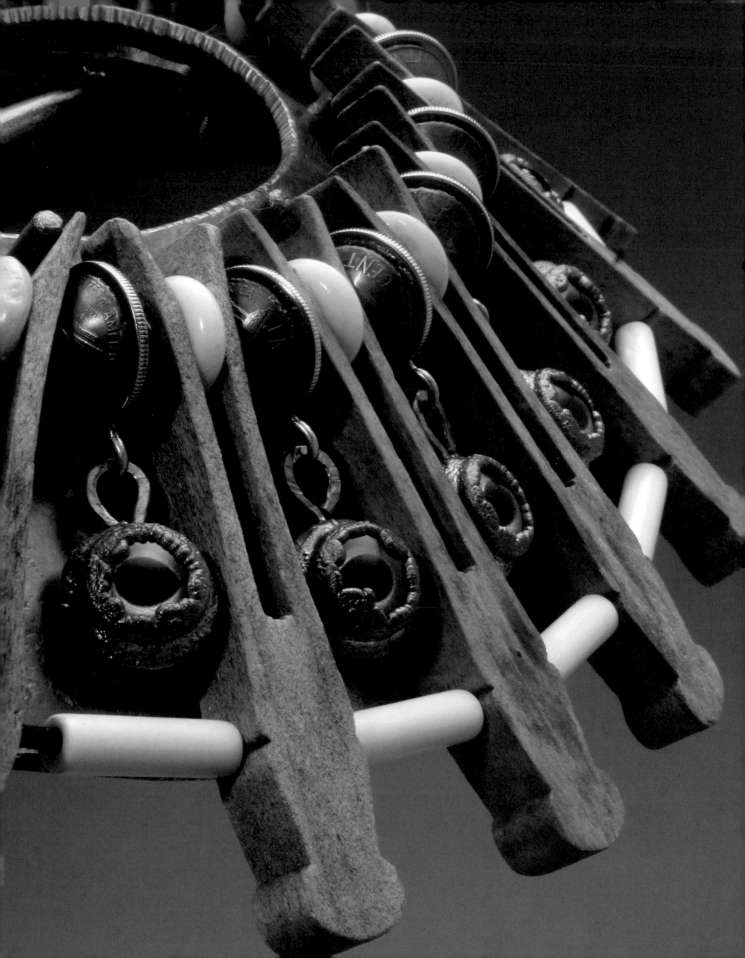

WORKS IN THE
EXHIBITION

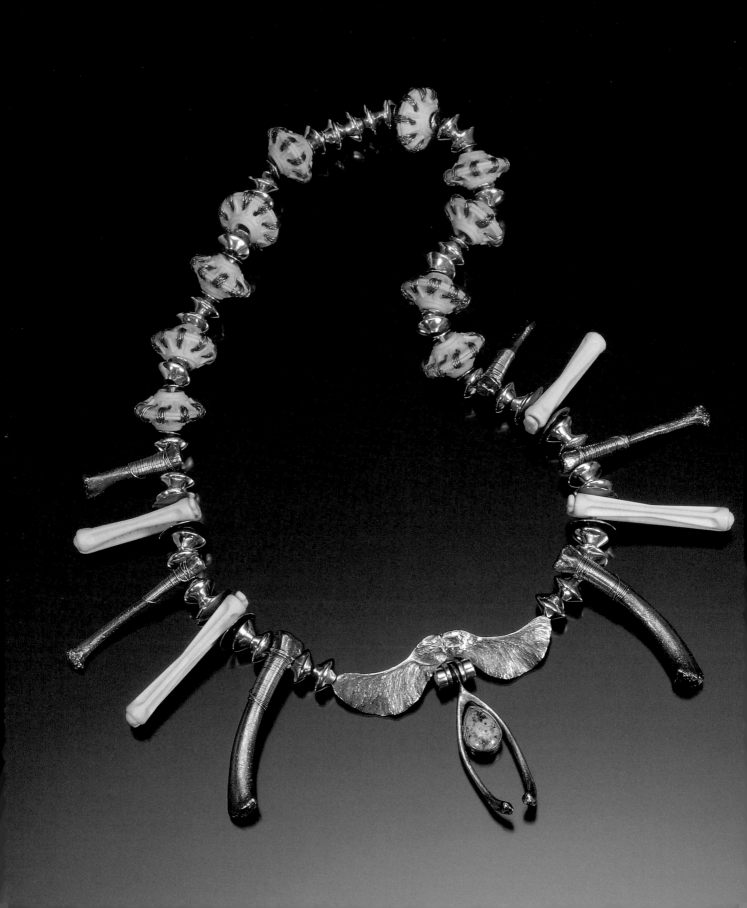

PLATE 1. *Initiation Necklace,* 1977. Silver, rhodonite, copper, pills set in epoxy, and plastic hair curlers, 27 (L) x 3 (W) x 1 ¼ (D) inches. Tacoma Art Museum, Gift of the artist.

PLATE 2. *Eyelet Lace,* 1984. Silver, plastic, and quartz, 3 (H) x 1 ¾ (W) x ¼ (D) inches. Collection of the artist.

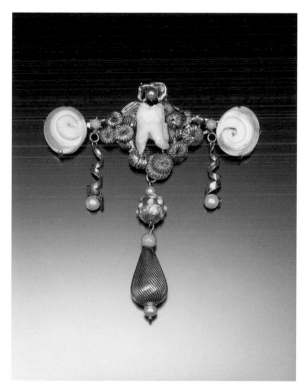

PLATE 3. *Venetian Vacation,* 1986. 14K gold, glass, pearls, shell, turquoise, and wisdom tooth, 3 ⅛ (H) x 3 ½ (W) x ½ (D) inches. Collection of Mia McEldowney.

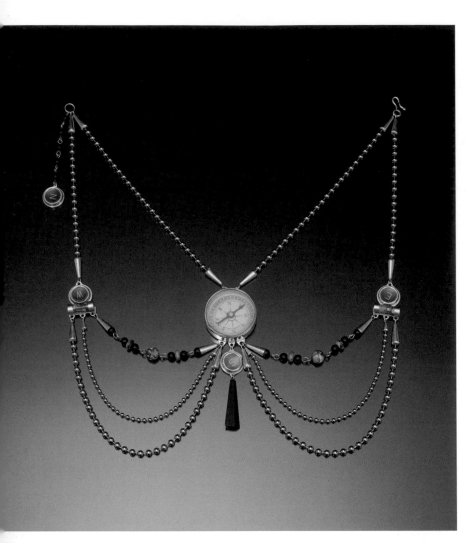

PLATE 4. *Which Way?,* 1989. Silver, jasper, onyx, typewriter keys, compass, and steel ball chain, 30 (L) x 5 (W) x ½ (D) inches. Collection of the artist.

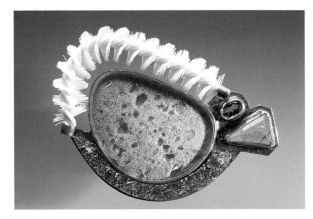

PLATE 5. *Bathroom Bowl Blues,* 1992. Silver, brass, tourmaline, rutilated quartz, eyeglass lens, sponge, wire, and bristle scrub brush, 2 ⅛ (H) x 3 ¼ (W) x ½ (D) inches. Racine Art Museum, Gift of the artist.

PLATE 6. *Broken Trust,* 1992. Silver, copper, garnet, malachite,
onyx, glass, and money, 19 ½ (L) x 2 (W) x ¼ (D) inches.
Tacoma Art Museum, Gift of the artist.

PLATE 7. *Runnin' Yo Mama Ragged,* 1992. Silver, plastic, amethyst, Monopoly charm, and laminated paper, 2 ⅝ (H) x 2 ⅝ (W) x ⅝ (D) inches. The Daphne Farago Collection, Collection of Museum of Fine Arts, Boston.

PLATE 8. *I Feel Pretty,* 1993. 24K gold, silver, cubic zirconia, quartz, garnet, glass, plastic, lace, and false eyelash, 2 ½ (H) x 3 ¼ (W) x ½ (D) inches. SM's - Stedelijk Museum 's-Hertogenbosch / NL.

PLATE 9. *Mixed Messages,* 1993. Silver, onyx, pearls, pebble, glass, plastic, paper grass, and candy, 2 ½ (H) x 3 ¼ (W) x ½ (D) inches. SM's - Stedelijk Museum 's-Hertogenbosch / NL.

PLATE 10. *Overprotective Impulse,* 1993. Silver, brass, glass, onyx, and paper, 2 ¼ (H) x 2 ¾ (W) x ½ (D) inches. Collection of the artist.

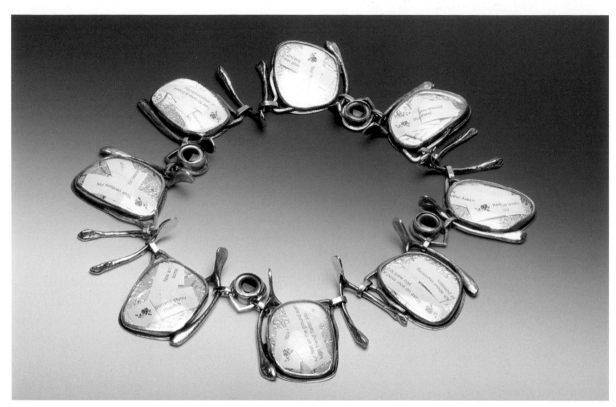

PLATE 11. *Family Fortune,* 1994. 18K gold, silver, glass eyes, glass lenses, fortune cookie fortunes, and candy wrappers, 20 (L) x 2 ½ (W) x ⅝ (D) inches. Collection of Laura Oskowitz.

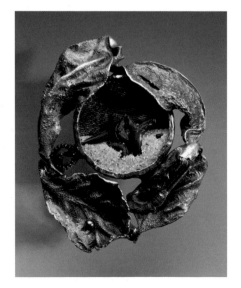

PLATE 12. *Hidden Agenda,* 1994. Silver, hematite, pearl, glass, sand, silk, and shark teeth, 2 ½ (H) x 3 (W) x ¾ (D) inches. Collection of Susan Beech.

PLATE 13. *The Seven Deadly Sins,* 1994. Silver, synthetic rubies, glass, plastic, steel, candy wrappers, broken mirror, brass, and laminated photographs, 20 ½ (L) x 2 (W) x ½ (D) inches. Museum of Arts & Design, New York, Gift of the artist and the William Traver Gallery, 1995.

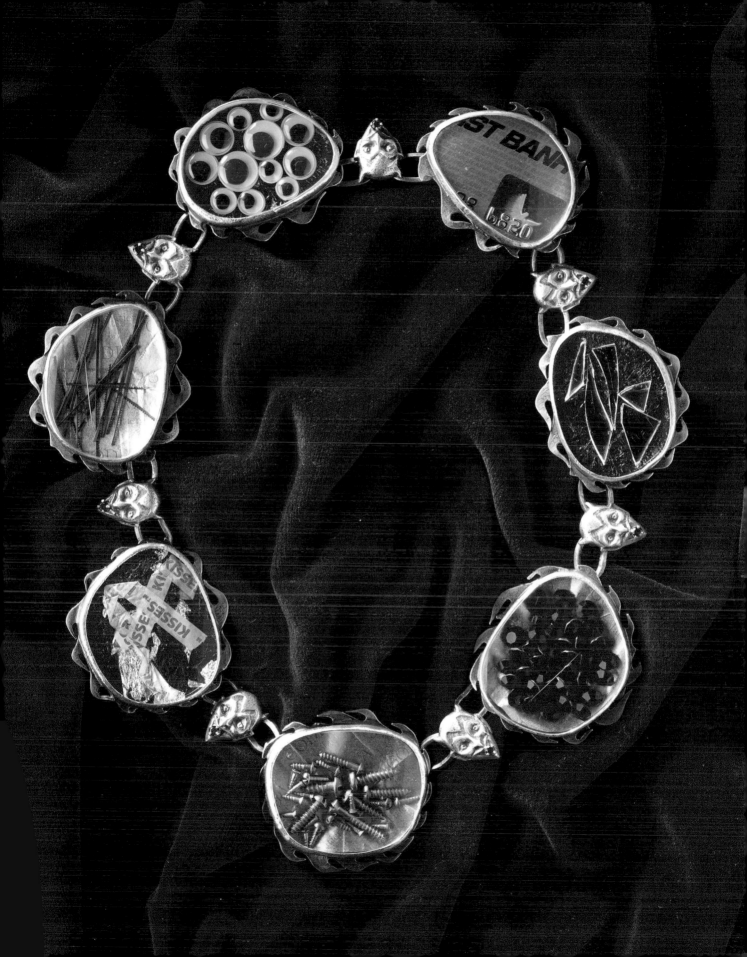

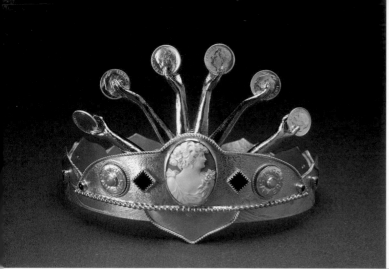

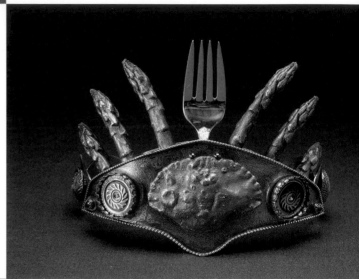

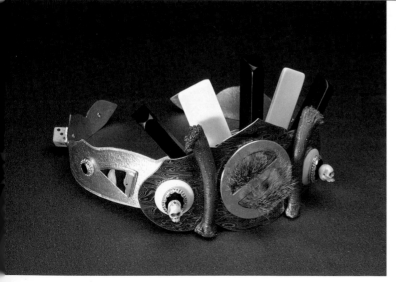

PLATE 14, PLATE 15, and PLATE 16. From top to bottom: *Charity Tiara, Hospitality Tiara, Politically Correct Tiara,* 1995, from the series *The Importance of Good Manners*. *Charity Tiara*: silver, gold-plated copper, shell cameo, moonstone, and onyx, 4 ½ (H) x 6 ½ (W) x 7 ½ (D) inches. *Hospitality Tiara*: silver, copper, shell, pearls, hematite, and beer bottle caps, 5 (H) x 6 ½ (W) x 7 ½ (D) inches. *Politically Correct Tiara*: silver, copper, onyx, jasper, ivory, bone, ebony, and fur, 4 ½ (H) x 6 ½ (W) x 7 ½ (D) inches. Seattle City Light 1% for Art Portable Works Collection.

PLATE 17. *Beans in Your Ears,* 1996. Silver, copper-plated bronze, 14K gold, lapis, glass, petrified dinosaur bone, plastic, dried beans, copper coins, and laminated photographs, 24 (L) x 3 ½ (W) x ¾ (D) inches. Collection of the artist.

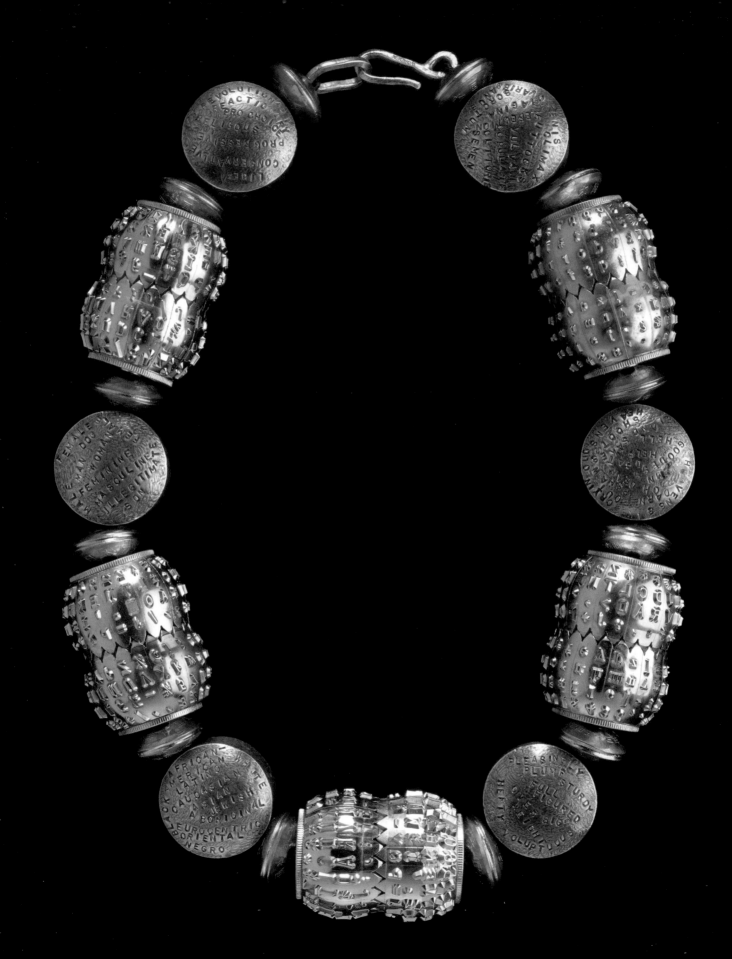

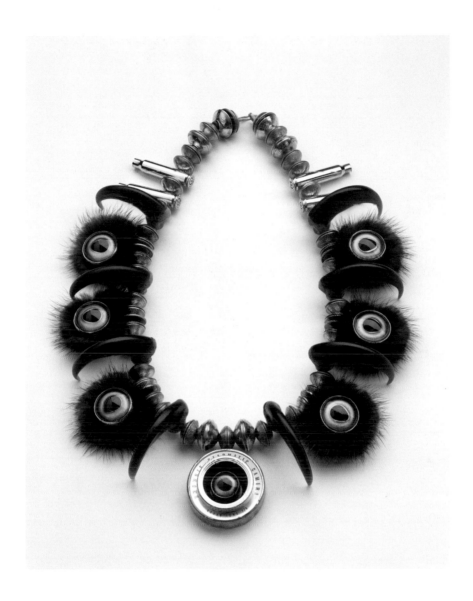

PLATE 18 (left). *Terminology,* 1996. Silver, brass coins, leather, and IBM Selectric typewriter parts, 23 (L) x 1 ½ (W) x 1 ½ (D) inches. The Daphne Farago Collection, Collection of Museum of Fine Arts, Boston.

PLATE 19 (above). *Dead or Alive,* 1997. Silver, brass, resin bear claws, mink, glass taxidermy eyes, leather, camera parts, and laminated photograph, 24 (L) x 2 ¾ (W) x 1 ½ (D) inches. Seattle Art Museum, Anne Gould Hauberg Northwest Crafts Fund and the Mark Tobey Estate Fund.

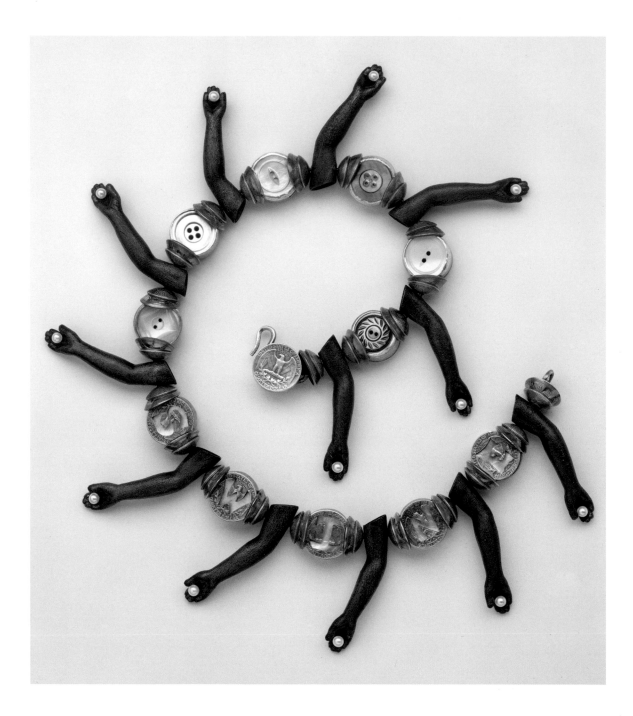

PLATE 20 (above). *Casting Pearls before Swine,* 1997. Silver, copper, brass, pearls, and mother-of-pearl buttons, 23 ½ (L) x 3 (W) x 1 (D) inches. Collection of Susan Beech.

PLATE 21 (right). *Armed and Dangerous,* 1998. Silver, 18K gold, malachite, plastic, onyx, brass, and money, 23 (L) x 5 (W) x ¾ (D) inches. Collection of the Boardman Family.

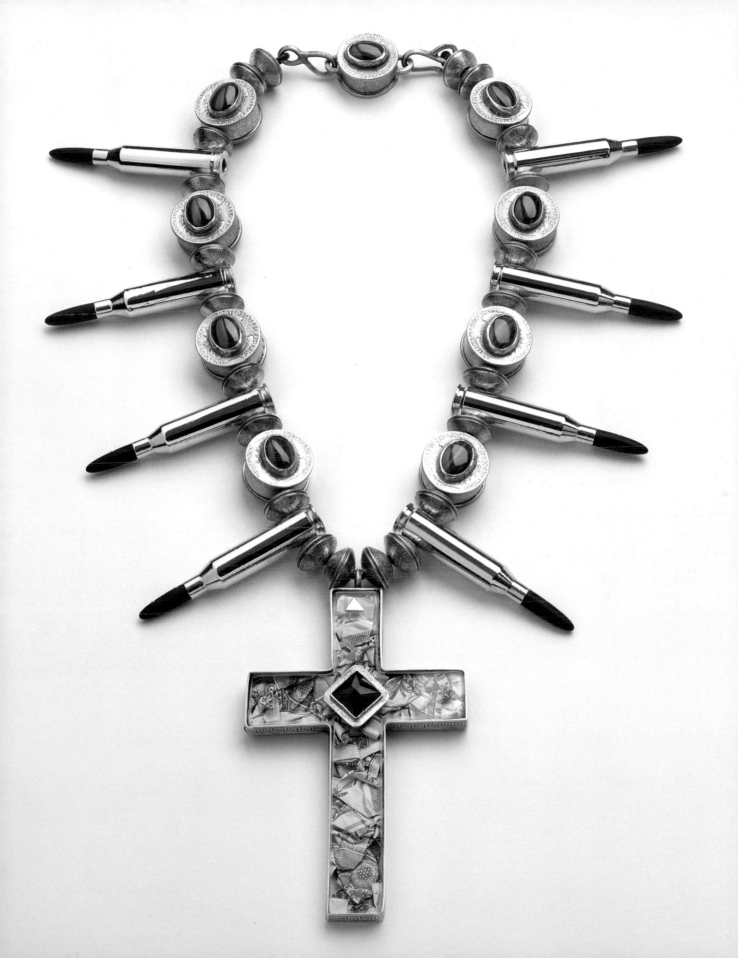

PLATE 22. *Diamonds and Lust,* 1998. 18K gold, silver, 22K gold settings, gold-plated copper and silver, pearls, money, candy wrappers, and laminated photograph, 23 (L) x 5 (W) x 1 (D) inches. SM's - Stedelijk Museum 's-Hertogenbosch / NL.

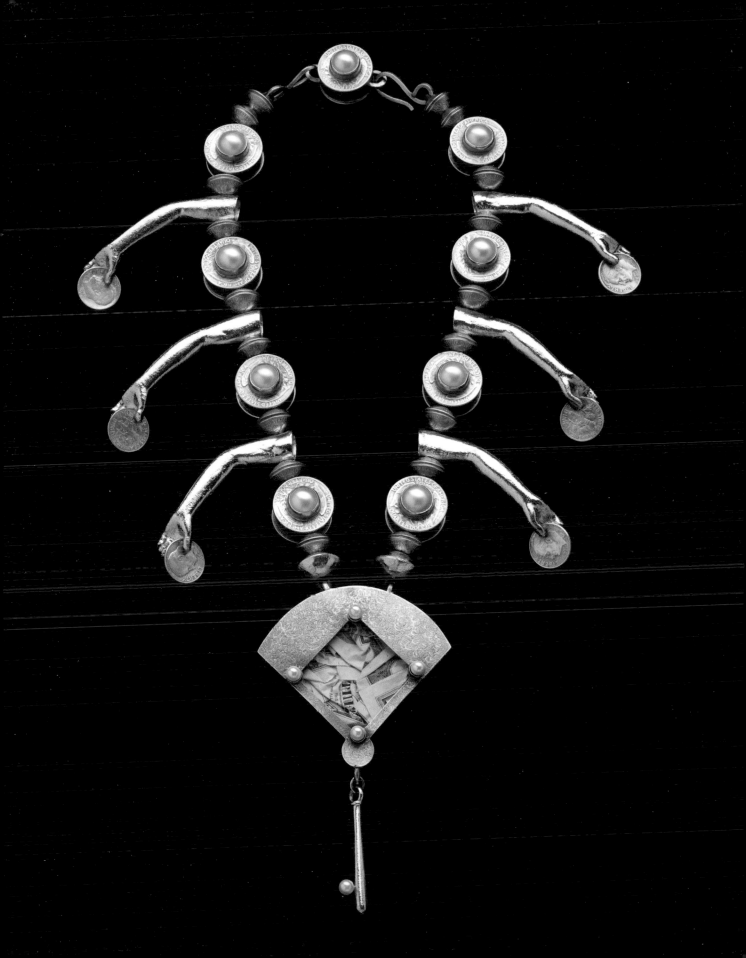

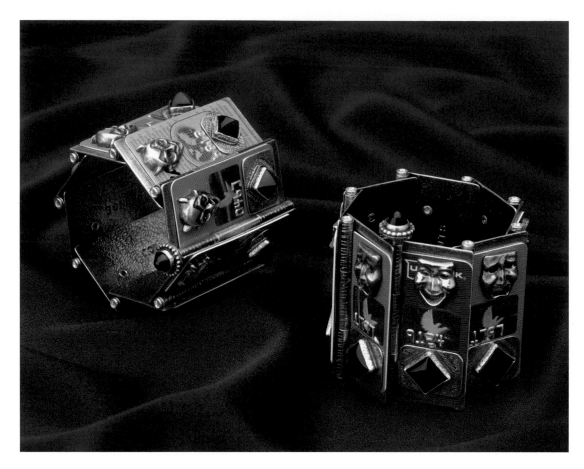

PLATE 23. Left: *Hologram Hell,* 1998. Silver, onyx, and credit cards, 8 (L) x 2 ½ (W) x ½ (D) inches. Collection of Lynn and Jeffrey Leff. Right: *Hologram Theater,* 1998. Silver, 14K gold, onyx, and credit cards, 8 (L) x 2 ½ (W) x ½ (D) inches. Collection of Laura Oskowitz.

PLATE 24. *Silence is Golden,* 1998. Silver, 18K gold, carnelian, rubber, laminated photograph, and old telephone parts, 19 (L) x 3 ¾ (W) x 1 (D) inches. Collection of Marion Fulk.

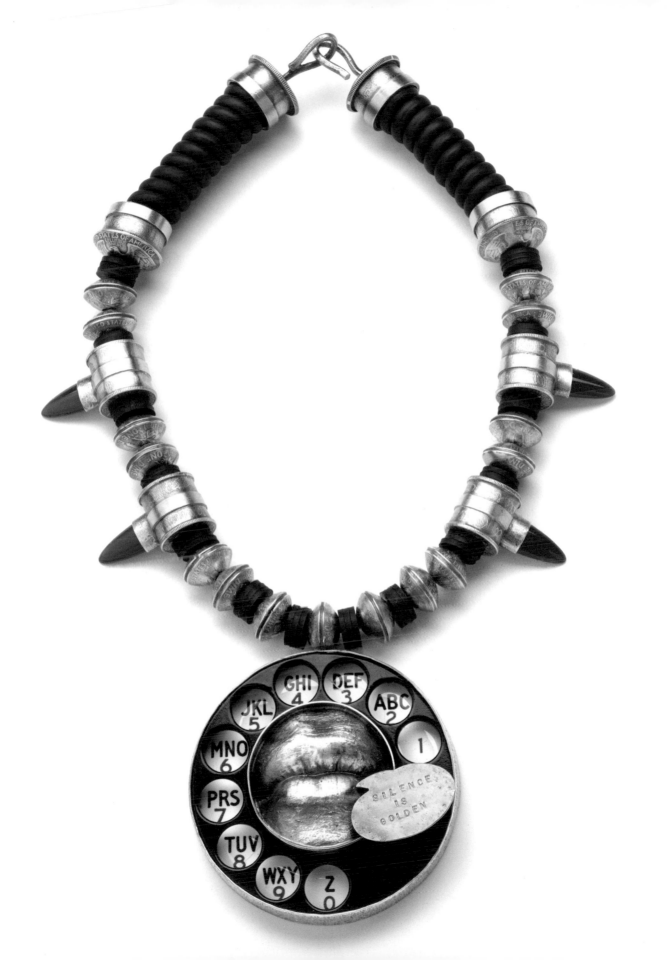

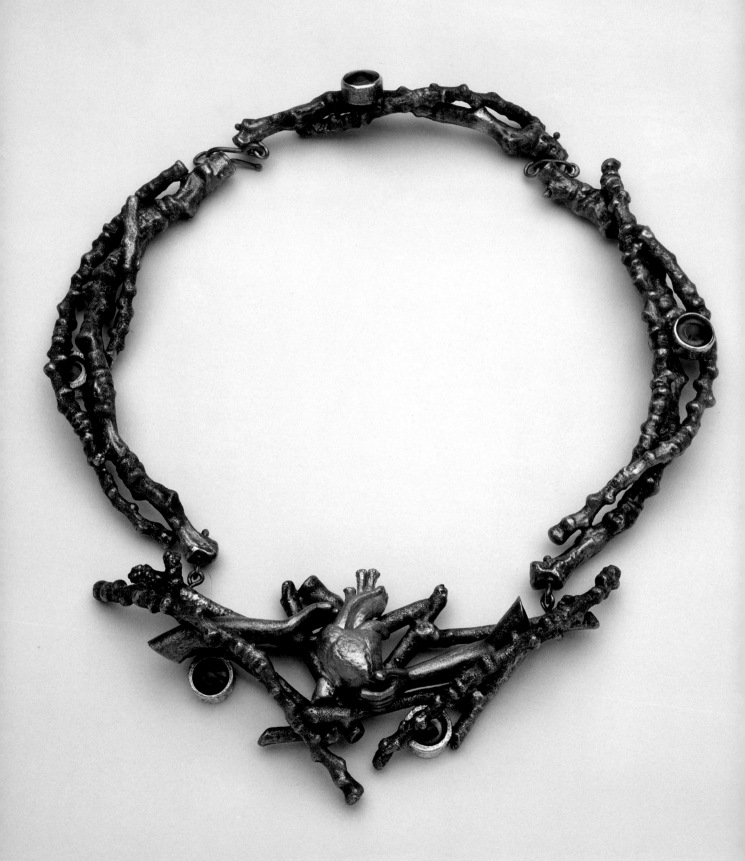

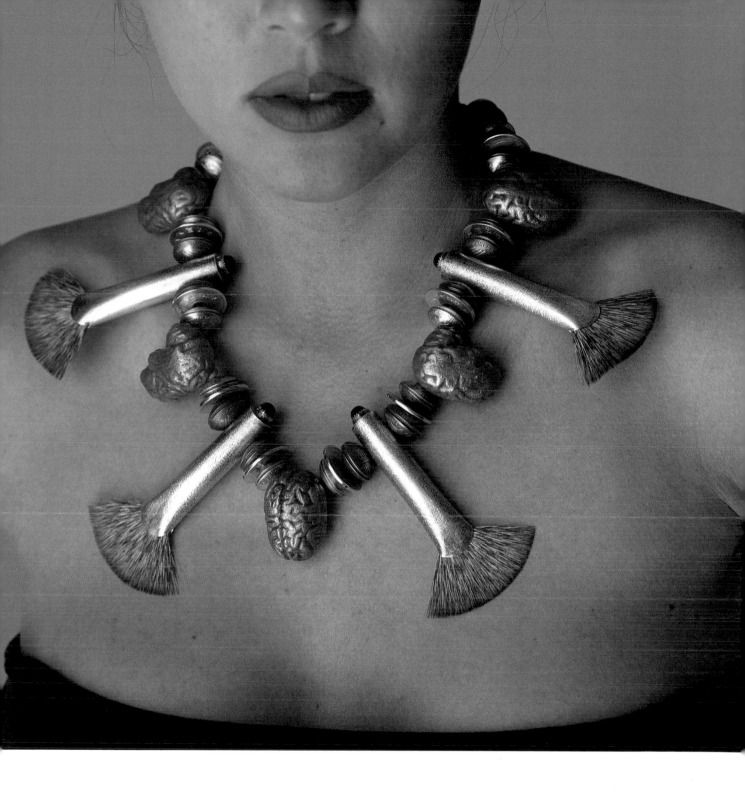

PLATE 25 (left). *Repairing the Nest,* 1999. Copper, silver, gold plate on copper, and glass eyes, 28 (L) x 3 ½ (W) x 1 ¼ (D) inches. Collection of Judith A. Whetzel.

PLATE 26 (above). *Balancing Right and Left,* 2000. Silver, copper, brass, onyx, and mongoose hair brushes, 19 (L) x 3 ¾ (W) x 1 ½ (D) inches. Collection of the Boardman Family.

PLATE 27. *Conjugal Bushwhacking,* 2000. Silver,
copper, glass eyes, mother-of-pearl, and lava, 23 (L)
x 5 ½ (W) x 1 ½ (D) inches. Collection of the artist.

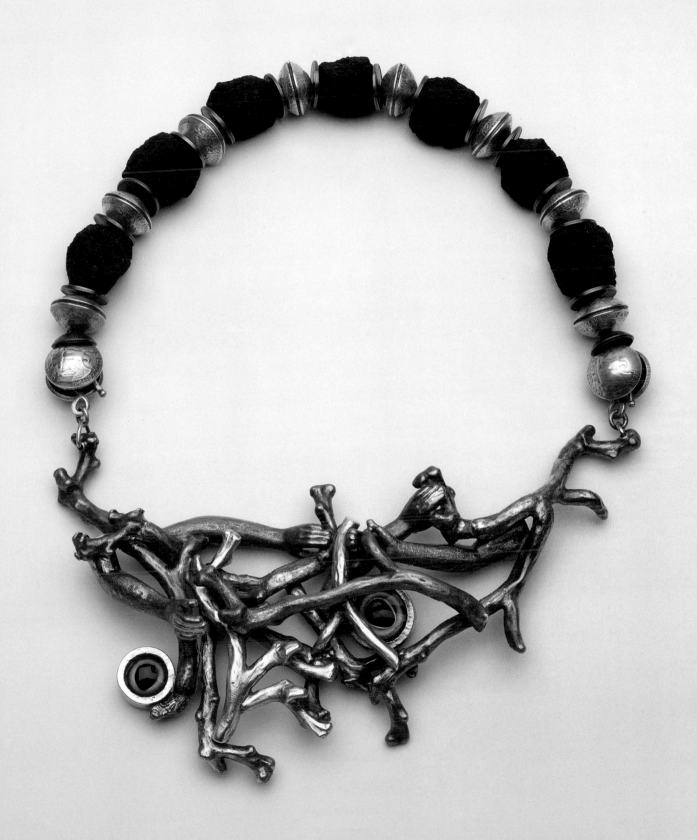

PLATE 28 (left, back) and PLATE 29 (above, front). *Gilding the Past,* 2001. Silver, gold-plated copper and silver, coral, brass, bone, cotton cord, and turquoise, 43 (L) x 4 ½ (W) x ¾ (D) inches. Collection of the Boardman Family.

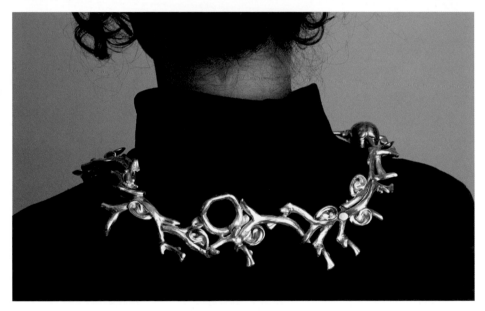

PLATE 30 (top) and PLATE 31 (bottom). *Grafting,* 2001.
14K gold, silver, and gold-plated copper, 24 (L) x 2 ½ (W)
x 1 ½ (D) inches. Collection of the Boardman Family.

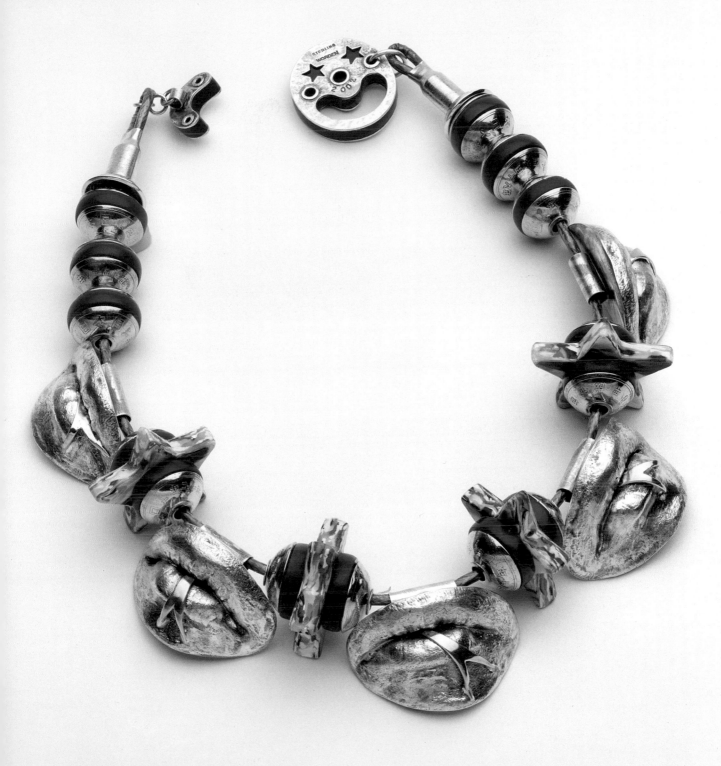

PLATE 32. *Vicious Circus,* 2002. Silver, brass, plastic,
plastic-coated steel cable, and gold plate, 20 (L) x
2 (W) x 1 ½ (D) inches. Collection of Jacqueline Fowler.

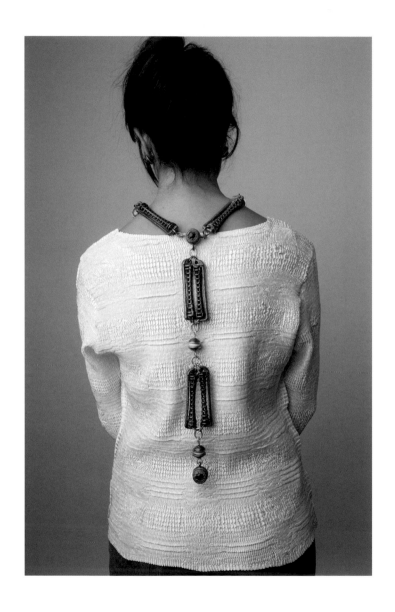

PLATE 33 (above) and PLATE 34 (right). *Exosquelette #1,* 2003. Silver, electroformed copper over plastic, nickel, bone, and glass eyes, 28 (H) x 1 ½ (W) x ¾ (D) inches. Collection of the artist.

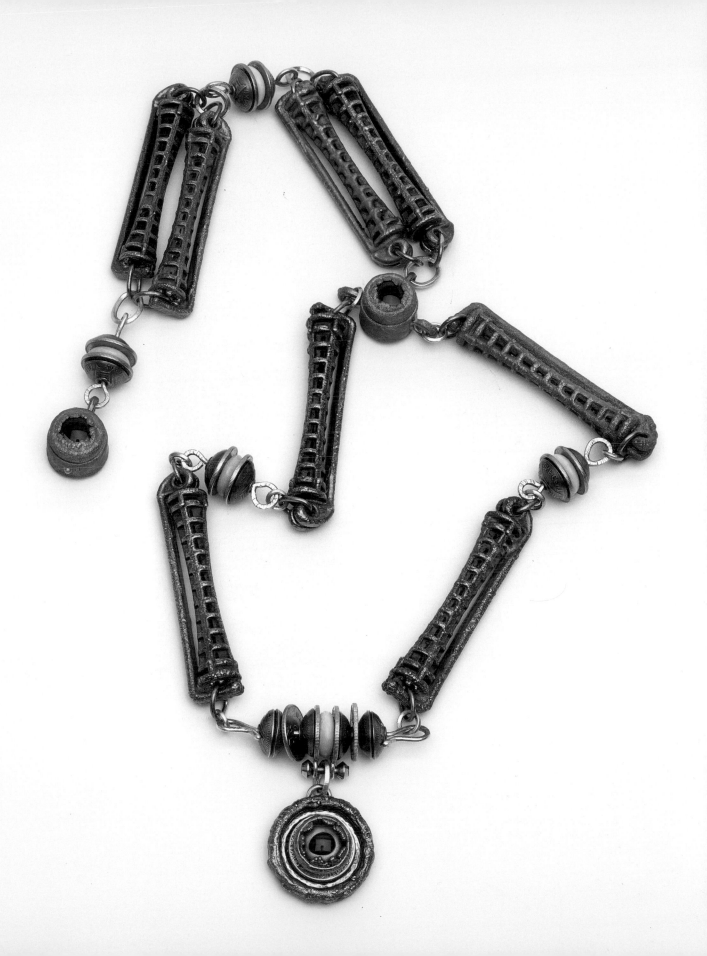

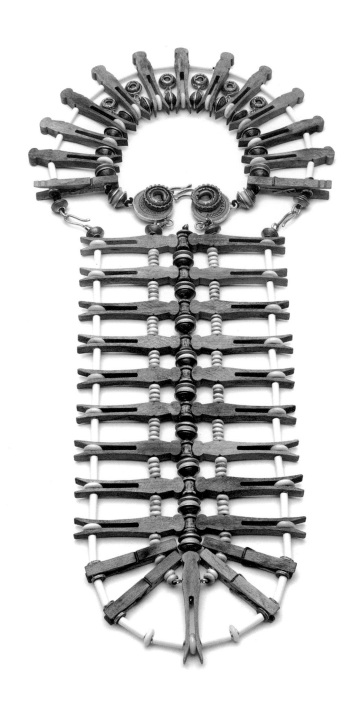

PLATE 35 (above), PLATE 36, (top right) and PLATE 37
(bottom right). *Exosquelette #2,* 2003. Copper, silver,
bone, nickel, wood clothespins, steel, glass eyes, and
cotton cord, 28 (H) x 12 ½ (W) x 1 (D) inches.
Collection of the artist.

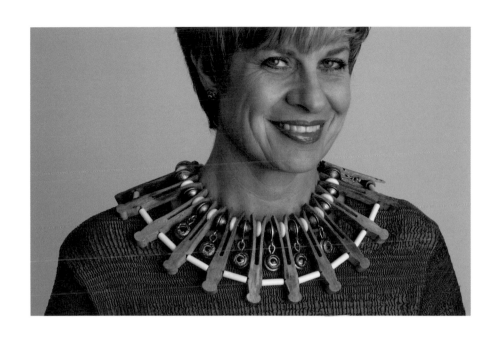

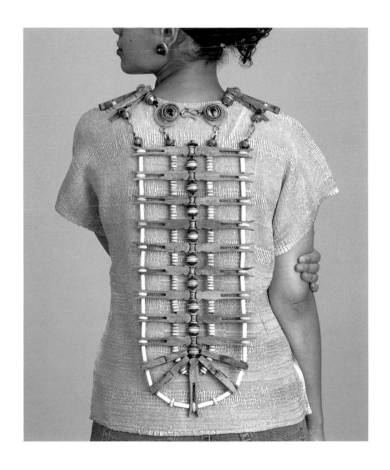

PLATE 38. *The Leash,* 2003. Silver, nickel, brass, fur, pearls, glass eye, and steel clip, 42 (H) x 4 (W) x 4 (D) inches. Collection of the Boardman Family.

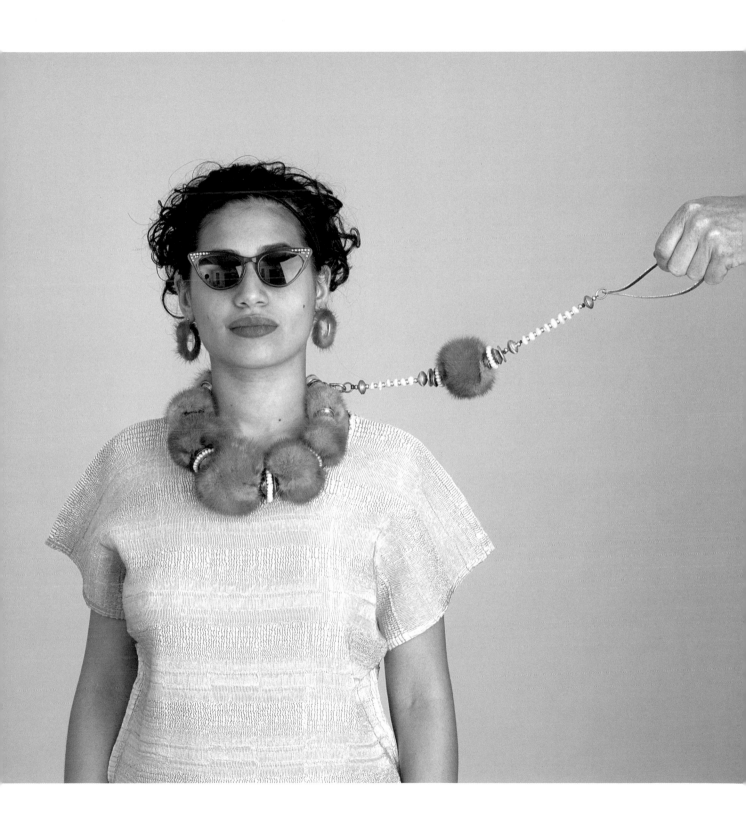

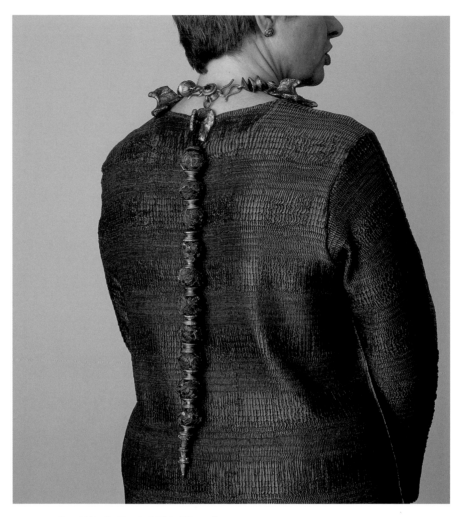

PLATE 39. *Ereshkigal's Hook,* 2004. Silver, electro-
formed copper, brass, steel, cork, reptile skin, cotton
cord, and glass eyes, 30 (H) x 1 ¾ (W) x 1 ⅜ (D)
inches. Collection of Marion Fulk.

PLATE 40. *The Good Omen,* 2004. Silver, steel,
concrete, and pebbles, 26 (L) x 2 ¼ (W) x ½ (D)
inches. Collection of the artist.

PLATE 41. *Frozen Dreams,* 2004. Silver, nickel-plated
copper, nickel coins, and acrylic, 20 (H) x 13 ½ (W) x
2 (D) inches. Collection of the artist.

PLATE 42 (above) and PLATE 43 (right). *Lifting Weights,* 2004. Silver, 14K white gold, lead weights, brass, glass eyes, ebony piano keys, bone, horn, cotton cord, and coins, 20 (H) x 10 ½ (W) x ¾ (D) inches. Collection of Susan Beech.

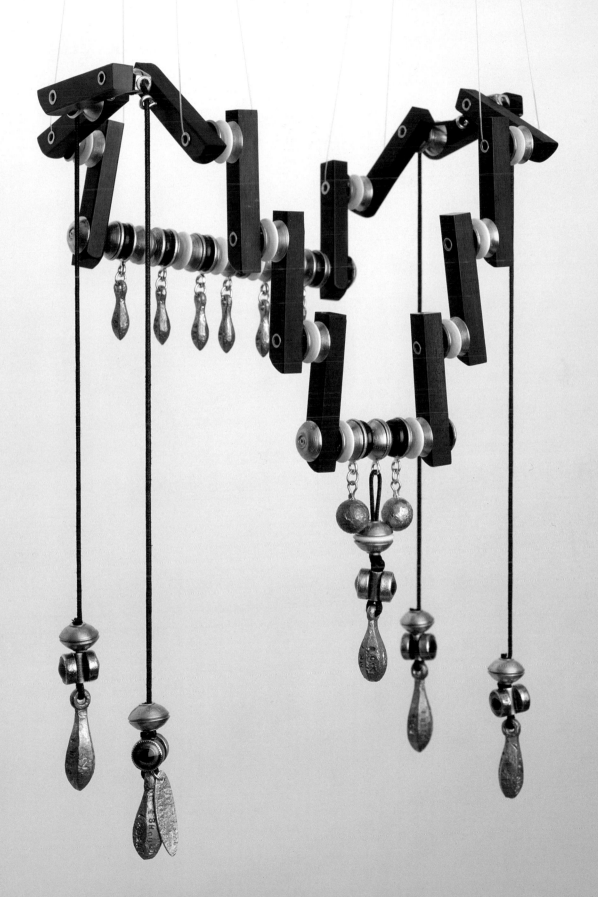

PLATE 44 (above) and PLATE 45 (right). *Brigandine for Ishtar,* 2005. Copper, brass, nickel, steel, lead, and glass eyes, 21 (H) x 16 (W) x 1 ½ (D) inches. Collection of the artist.

PLATE 46 (above) and PLATE 47 (right). *Electric Fence,*
2007. Steel, copper, painted porcelain, and bone, 16 ½
(H) x 14 (W) x 2 (D) inches. Collection of the artist.

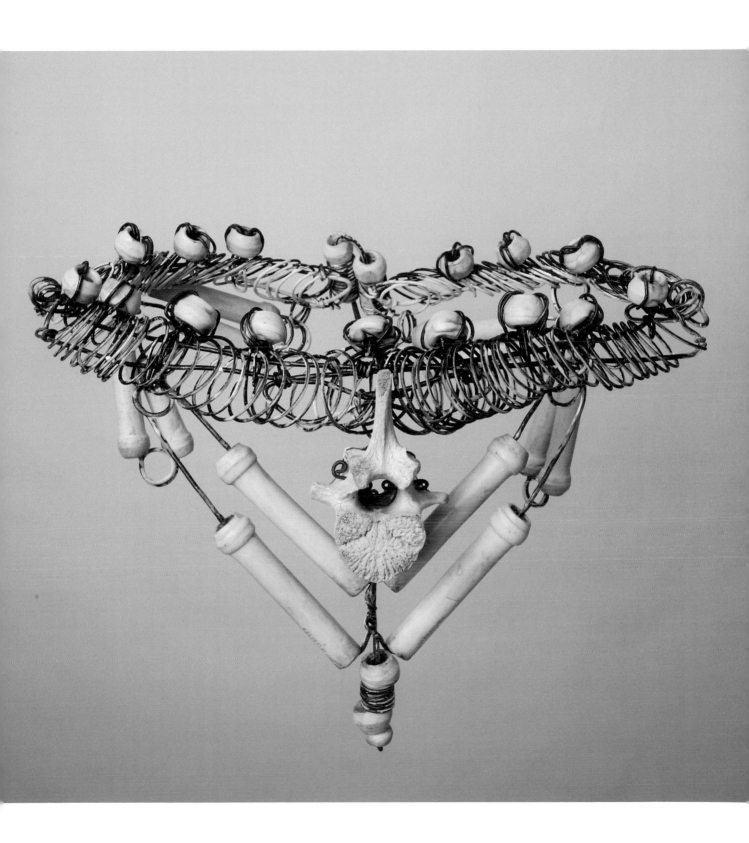

PLATE 48. *Literal Defense,* 2007. Aluminum, silver, brass, copper, glass eyes, vintage glass, 23K gold leaf, plastic, and leather, 24 (H) x 13 (W) x 5 (D) inches. Collection of the artist.

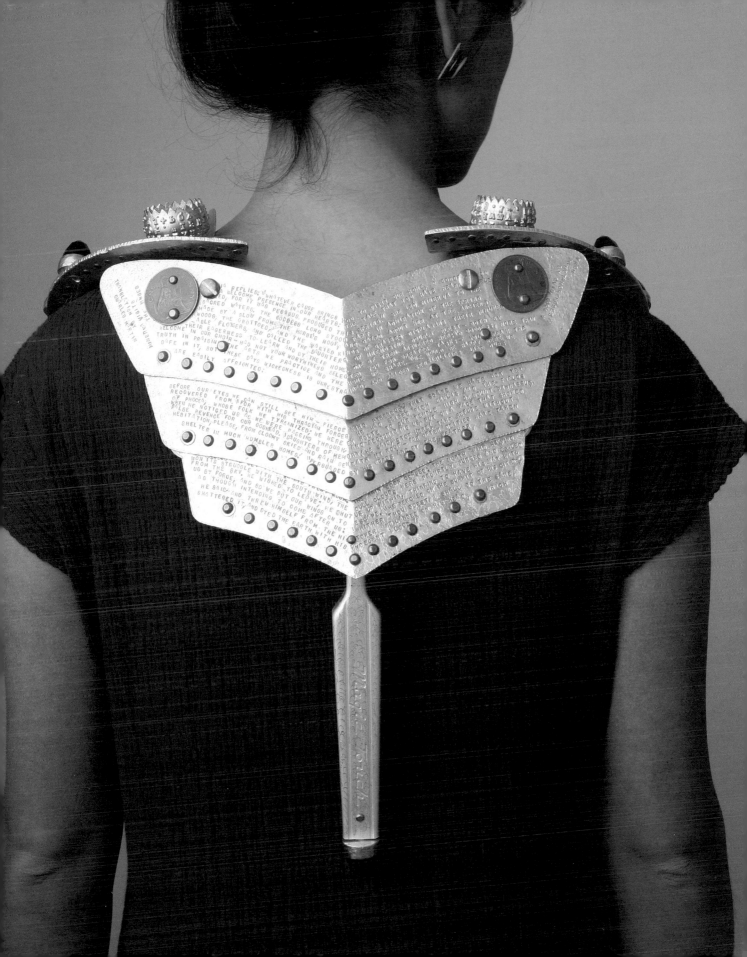

Nancy Worden in her studio, 2008

INTERVIEW WITH NANCY WORDEN

Rock Hushka

RH: Materials are the fulcrum of meaning in your jewelry. When you combine a traditional jewelry form with heavily symbolic materials—plastic hair curlers, bullets, typewriter balls, glass eyes for taxidermy, snake skin, and so forth—your presence becomes unmistakable. How do you approach or manage the symbolism of the materials with the design of the works, your knowledge of historic forms, and your aesthetic sensibility? Have you found that one aspect of this process is more important than the others?

NW: The idea is paramount. Everything else, the composition, techniques, historical reference, and my choice of materials, is determined by the idea. Without a very clear idea of what the piece is about, it is easy to get sidetracked and seduced by the materials. Throughout the design process, I keep checking to make sure I'm not straying from the original idea. As cluttered as some of the works may appear, every object has been evaluated and deemed necessary. Anything extra would detract from the idea.

Finding and choosing the materials for each idea can be really hard, and it is usually the most time-consuming part of the design process. In the past, I spent a lot of time trolling for textures and colors and shapes in thrift stores. Now I have to spend a little more money and go to antique malls to find the same kind of inventory. I have become an archeologist of sorts, hunting for artifacts from a specific time in American culture. Scale is important; locating the right materials to convey that idea, within the physical limitations of size and weight appropriate for jewelry, really narrows the hunt. I often try and discard many different objects until I get the right combination of form, color, and content. This has become an intuitive process, and I have learned to trust my gut. Often I will find something interesting and not actually use it for many years. Things sit around until an appropriate idea comes along. I think this is one of the main differences between how I use found objects and how other artists use them. Others find the object and make a piece around it. I always start with the idea and then figure out the materials.

I began using found objects when I was in college as a way to get color and texture into my work. As I became more sophisticated, my focus became blending things like bits of vintage plastic from old eyeglasses or buttons with a gemstone to create a visual relationship. In the early work it was all just about blending shapes and color. For instance, I once combined

petrified wood in the same brooch with wood-grain Formica that matched the stone. Eventually, I realized the man-made objects contributed a particular historical and cultural reference too. In this way, I was slowly developing a vocabulary. Incorporating glass eyeballs also started in school as a way to make an animal reference. I still use them for animal as well as amulet references or sometimes just to create a spooky or ominous feeling.

When I brought the narrative element back into my work in the early 1990s, I added yet another layer to the vocabulary. The work I did then, the *Middle-Aged Mom* series, started out kind of cute and literal with charm-size cast forms. Gradually, I worked on implying the narrative instead of spelling it out, letting the found materials dominate and pretty much eliminating the little castings. Currently, anything miniature is not part of my vocabulary. All the elements must be life-size now.

RH: Both Professor LeBaron and Dr. Platt wrote about the universal meanings in your work, particularly with the *Middle-Aged Mom* series. You have stressed in conversation with me that the primary meaning of these works comes from your own experience. When a work of art is presented in a museum, the goal is for people to understand both these aspects of meaning. How do you reconcile these two sometimes-contradictory aspects?

NW: I don't consider them contradictory. Artists are constantly making observations of the world around them, and my work always starts with something I have experienced or observed. However, I'm not a reporter, and if I limited my observations to reporting an exact

situation, I wouldn't be making art. All artists filter their observations through their own vocabulary, be it film or dance or music or jewelry, in such a way that their audience can recognize something in the work. That is the universal quality you try for, that recognition. I consider a brooch or necklace a success if I can wear it in front of total strangers and have them react in such a way that is relevant to my idea and their own experience. It's a hard thing to pull off so I have ways of testing the pieces.

When I began the *Middle-Aged Mom* series, I was frequenting a print shop near my home for Xeroxing and laminating. The woman who worked there and made copies for me was my age and a mom, but she lived in a very different world than I did, definitely not the art world. One time I wore one of my necklaces in, and she laughed and made a comment that let me know she really got it. After that, I started deliberately wearing something I'd just finished to get her reaction. I trusted her honesty more than my artist peers.

After she left the shop, I had to find other testers. I get some of my best feedback right now from the security people at airports. They have to snoop through your things, and I'm guessing they see a lot of the same kind of stuff; they almost always comment. Because my work is large and unusual, whenever I wear it I hear comments from waitresses, museum guards, and people on the street.

Museum curators often give me feedback about my work too. When the Museum of Fine Arts in Boston first exhibited the Daphne Farago Collection, the curators had a tough time choosing which pieces to show. The

collection includes more than six hundred pieces of jewelry and there was room to show only a couple hundred of them at a time. At first they planned to show only my necklace *Terminology* (1996; frontispiece; plate 18, page 76) and brooch *Lend Me Your Ears* (1993; fig. 38, page 53), but when they saw *Runnin' Yo Mama Ragged* (1992; plate 7, page 70), they decided to show all three. As both were young mothers, they could really relate to the imagery, and they knew other young mothers would too. That's what I mean about people recognizing themselves in the work.

Another aspect that museum and gallery audiences like is the story behind the work. During my *Modern Artifacts* show at the Traver Gallery in 2005, I got fan mail from women I didn't know who came to see the show. That was the first show where we put the story on the label for each work, and now I always do it. Only once have I heard negative feedback from a show. At one of my openings in the late 1990s at the Traver Gallery in Seattle, a woman came up to me and said, "You have a lot of nerve charging these kinds of prices for this junk." I didn't argue with her; I do have a lot of nerve.

RH: The idea of jewelry as "miniature sculpture" is one that you have rejected as a tool to understand your work. You favor, instead, an emphasis on the history of jewelry and the evolution of traditional forms. Would you elaborate as to why this is a crucial difference in understanding not only individual works but also the arc of your career?

NW: In the 1970s, you would occasionally hear jewelry artists defend their work with the label "miniature sculpture" because it was so difficult to describe what studio jewelry was. Most people, even the makers, were ignorant of the history of jewelry. Jewelry has a historical tradition as old as human culture, and it has *always* been an art form designed for the context of the human body, unlike sculpture, which is freestanding. However, because jewelry was assigned a decorative arts designation by art historians, its history simply wasn't taught in art history classes, and in most schools it probably still isn't. I remember trying to do research for a paper in graduate school, and at that time, 1979, the only books that I could find in the University of Georgia library were books on costume, not jewelry. There has been an explosion of books on jewelry in the last twenty years, and that has really helped to educate all of us on its unique history, myself included.

My early interest in and knowledge of older traditions was gleaned from a lot of sources. Since there weren't many books when I started, I learned about ethnic jewelry from sources like *Arizona Highways* and *National Geographic*. Ramona Solberg collected all kinds of ethnic jewelry, and I think the first time I saw that type of ornament was at a show of her collection at the Ellensburg Community Art Gallery. The annual rodeo parade in Ellensburg also provided an ornamental feast of beaded costumes and regalia made by women of the Yakama tribe as well as the silver-encrusted saddles of the King County Sheriff's Posse. On a road trip to the Southwest in 1973, I saw a lot of native work in the museums. On a visit to see my grandparents in 1975, I saw a collection of hair jewelry at the Peabody

Museum in Salem, Massachusetts. Wherever I was, jewelry seemed to jump out at me. Since I didn't want to make work that looked like my contemporaries, I focused on looking at the older and non-Western traditions, and I still do.

When you are combining a lot of odd materials together, it is challenging to create some kind of compositional structure that is both conceptually and visually graceful. Historical jewelry offers so many different solutions that have already been tested as wearable and beautiful, and that is where I go when I need a solution. Ultimately, however, my choice to be a maker of jewelry really comes down to the personal and intimate relationships that jewelry has in people's lives. That is the hook that grabs me. Sentimentality is inherent in the history of the art form, whether you choose to address it or not. Wedding rings, hero medals, amulets, affiliation badges, and ostentatious display are tightly woven into the fiber of human rituals and mythology. They are all a part of the psychological tapestry where I find my ideas.

RH: As your career has developed and your influence has expanded, what have you learned that has influenced your thinking most?

NW: Recognizing and understanding exactly who I am has been the most important thing I've learned. I am an American woman, born in the mid-twentieth century, and I came of age at a time when women's roles were changing. I am Caucasian, middle class, college-educated, married, and a mother. The importance of knowing who and what you are in the search to find your own voice is paramount. The more I travel, the better I understand what being American is, and that it is the only culture I truly understand. It makes me sad to see artists who are always trying on someone else's style or appropriating another culture from a country they have only visited. I'm not saying you should stop challenging yourself and crank out the same thing because it sells, however. The painter Chuck Close (born 1940) said, "When everything in the world was a possibility I only tried three or four things over and over. . . . Once I decided I was going to have relatively severe limitations, everything opened up." Within the boundaries of my vocabulary, my culture, my experiences, and the context of the body, I have more ideas than I will ever be able to make.

RH: Much has been written and discussed about the arc of craft and art in the Northwest. For the past thirty years, you have been an integral part of these dialogues, both as a participant and a subject. What has been constant over these years? What has shifted most?

NW: I've been lucky to live in an area where there are so many artists working in all media. Especially in Seattle, art is valued and visible all over the place: in airports, schools, libraries, even grocery stores. The One Percent for Art laws created a whole culture of professional artists, not teachers, that younger artists like me could learn from. When I first came to the city in 1981, the art community was pretty small, and we all knew each other. Whenever there was a gallery opening, all the artists were there. I cannot overemphasize the importance of that nurturing community. We have a larger

scene now, and I don't know everybody anymore, but the support system is still strong and especially visible at places like the Pratt Fine Arts Center, Artist Trust, and 4Culture. I have visited a lot of other cities and can appreciate just how rare what we have here is.

The changes I've observed have happened mostly because of cross-pollination. When I was growing up and going to school, there seemed to be certain styles of art tied to our region or specific professors at the schools. Washington State University turned out figurative painters and the University of Washington painters were more abstract. Central Washington University, where I went to school, produced jewelry artists influenced by Ramona Solberg, Don Tompkins, and Ken Cory, who often focused on narrative ideas. Mary Hu and John Marshall, the metals professors at the University of Washington, were focused on imagery found in technique. Now, with all the new books on studio jewelry and more interaction with European artists, regional styles are a thing of the past. Today's students also go farther afield to get an education than my generation did: we went to the state schools closer to home. I'm not saying this is a bad thing, because we went to good schools; it's just different. A definable regional style is no longer obvious to me.

Another change I see now in many art schools locally and nationwide is a greater emphasis on installation and technology and less on skills and technique. This is alarming to me; it takes a long time and hard work to really master a skill, and these new programs encourage students to dabble in many disciplines instead of mastering one or two. I'm not convinced these students understand what goes into making a quality object. I'm concerned about the next generation: what will they have to sell and will their work survive the test of time?

EXHIBITION CHECKLIST

Initiation Necklace 1977
Silver, rhodonite, copper, pills set
in epoxy, and plastic hair curlers
27 (L) x 3 (W) x 1 ¼ (D) inches
Tacoma Art Museum, Gift of the artist

Eyelet Lace 1984
Silver, plastic, and quartz
3 (H) x 1 ¾ (W) x ¼ (D) inches
Collection of the artist

Venetian Vacation 1986
14K gold, glass, pearls, shell,
turquoise, and wisdom tooth
3 ⅛ (H) x 3 ½ (W) x ½ (D)
inches
Collection of Mia McEldowney

Which Way? 1989
Silver, jasper, onyx, typewriter
keys, compass, and steel ball
chain
30 (L) x 5 (W) x ½ (D) inches
Collection of the artist

Bathroom Bowl Blues 1992
Silver, brass, tourmaline, rutilated
quartz, eyeglass lens, sponge,
wire, and bristle scrub brush
2 ⅛ (H) x 3 ¼ (W) x ½ (D)
inches
Racine Art Museum, Gift of the artist

Broken Trust 1992
Silver, copper, garnet, malachite,
onyx, glass, and money
19 ½ (L) x 2 (W) x ¼ (D) inches
Tacoma Art Museum, Gift of the artist

Runnin' Yo Mama Ragged 1992
Silver, plastic, amethyst,
Monopoly charm, and laminated
paper
2 ⅝ (H) x 2 ⅝ (W) x ⅝ (D)
inches
The Daphne Farago Collection,
Collection of Museum of Fine Arts,
Boston

I Feel Pretty 1993
24K gold, silver, cubic zirconia,
quartz, garnet, glass, plastic, lace,
and false eyelash
2 ½ (H) x 3 ¼ (W) x ½ (D)
inches
SM's - Stedelijk Museum
's-Hertogenbosch / NL

Mixed Messages 1993
Silver, onyx, pearls, pebble, glass,
plastic, paper grass, and candy
2 ½ (H) x 3 ¼ (W) x ½ (D)
inches
SM's - Stedelijk Museum
's-Hertogenbosch / NL

Overprotective Impulse 1993
Silver, brass, glass, onyx, and
paper
2 ¼ (H) x 2 ¾ (W) x ½ (D)
inches
Collection of the artist

Family Fortune 1994
18K gold, silver, glass eyes, glass
lenses, fortune cookie fortunes,
and candy wrappers
20 (L) x 2 ½ (W) x ⅝ (D) inches
Collection of Laura Oskowitz

Hidden Agenda 1994
Silver, hematite, pearl, glass,
sand, silk, and shark teeth
2 ½ (H) x 3 (W) x ¾ (D) inches
Collection of Susan Beech

The Seven Deadly Sins 1994
Silver, synthetic rubies, glass,
plastic, steel, candy wrappers,
broken mirror, brass, and
laminated photographs
20 ½ (L) x 2 (W) x ½ (D) inches
Museum of Arts & Design, New York,
Gift of the artist and the William Traver
Gallery, 1995

Charity Tiara 1995
From the series *The Importance of Good Manners*
Silver, gold-plated copper, shell cameo, moonstone, and onyx
4 ½ (H) x 6 ½ (W) x 7 ½ (D) inches
Seattle City Light 1% for Art Portable Works Collection

Hospitality Tiara 1995
From the series *The Importance of Good Manners*
Silver, copper, shell, pearls, hematite, and beer bottle caps
5 (H) x 6 ½ (W) x 7 ½ (D) inches
Seattle City Light 1% for Art Portable Works Collection

Politically Correct Tiara 1995
From the series *The Importance of Good Manners*
Silver, copper, onyx, jasper, ivory, bone, ebony, and fur
4 ½ (H) x 6 ½ (W) x 7 ½ (D) inches
Seattle City Light 1% for Art Portable Works Collection

Beans in Your Ears 1996
Silver, copper-plated bronze, 14K gold, lapis, glass, petrified dinosaur bone, plastic, dried beans, copper coins, and laminated photographs
24 (L) x 3 ½ (W) x ¾ (D) inches
Collection of the artist

Terminology 1996
Silver, brass coins, leather, and IBM Selectric typewriter parts
23 (L) x 1 ½ (W) x 1 ½ (D) inches
The Daphne Farago Collection, Collection of Museum of Fine Arts, Boston

Casting Pearls before Swine 1997
Silver, copper, brass, pearls, and mother-of-pearl buttons
23 ½ (L) x 3 (W) x 1 (D) inches
Collection of Susan Beech

Dead or Alive 1997
Silver, brass, resin bear claws, mink, glass taxidermy eyes, leather, camera parts, and laminated photograph
24 (L) x 2 ¾ (W) x 1 ½ (D) inches
Seattle Art Museum, Anne Gould Hauberg Northwest Crafts Fund and the Mark Tobey Estate Fund

Armed and Dangerous 1998
Silver, 18K gold, malachite, plastic, onyx, brass, and money
23 (L) x 5 (W) x ¾ (D) inches
Collection of the Boardman Family

Diamonds and Lust 1998
18K gold, silver, 22K gold settings, gold-plated copper and silver, pearls, money, candy wrappers, and laminated photograph
23 (L) x 5 (W) x 1 (D) inches
SM's - Stedelijk Museum 's-Hertogenbosch / NL

Hologram Hell 1998
Silver, onyx, and credit cards
8 (L) x 2 ½ (W) x ½ (D) inches
Collection of Lynn and Jeffrey Leff

Hologram Theater 1998
Silver, 14K gold, onyx, and credit cards
8 (L) x 2 ½ (W) x ½ (D) inches
Collection of Laura Oskowitz

Silence is Golden 1998
Silver, 18K gold, carnelian, rubber, laminated photograph, and old telephone parts
19 (L) x 3 ¾ (W) x 1 (D) inches
Collection of Marion Fulk

Repairing the Nest 1999
Copper, silver, gold plate on copper, and glass eyes
28 (L) x 3 ½ (W) x 1 ¼ (D) inches
Collection of Judith A. Whetzel

Balancing Right and Left 2000
Silver, copper, brass, onyx, and mongoose hair brushes
19 (L) x 3 ¾ (W) x 1 ½ (D) inches
Collection of the Boardman Family

Conjugal Bushwhacking 2000
Silver, copper, glass eyes, mother-of-pearl, and lava
23 (L) x 5 ½ (W) x 1 ½ (D) inches
Collection of the artist

Gilding the Past 2001
Silver, gold-plated copper and silver, coral, brass, bone, cotton cord, and turquoise
43 (L) x 4 ½ (W) x ¾ (D) inches
Collection of the Boardman Family

Grafting 2001
14K gold, silver, and gold-plated copper
24 (L) x 2 ½ (W) x 1 ½ (D) inches
Collection of the Boardman Family

Vicious Circus 2002
Silver, brass, plastic, plastic-coated steel cable, and gold plate
20 (L) x 2 (W) x 1 ½ (D) inches
Collection of Jacqueline Fowler

Exosquelette #1 2003
Silver, electroformed copper over plastic, nickel, bone, and glass eyes
28 (H) x 1 ½ (W) x ¾ (D) inches
Collection of the artist

Exosquelette #2 2003
Copper, silver, bone, nickel, wood clothespins, steel, glass eyes, and cotton cord
28 (H) x 12 ½ (W) x 1 (D) inches
Collection of the artist

The Leash 2003
Silver, nickel, brass, fur, pearls, glass eye, and steel clip
42 (II) x 4 (W) x 4 (D) inches
Collection of the Boardman Family

Ereshkigal's Hook 2004
Silver, electroformed copper, brass, steel, cork, reptile skin, cotton cord, and glass eyes
30 (H) x 1 ¾ (W) x 1 ⅜ (D) inches
Collection of Marion Fulk

Frozen Dreams 2004
Silver, nickel-plated copper, nickel coins, and acrylic
20 (H) x 13 ½ (W) x 2 (D) inches
Collection of the artist

The Good Omen 2004
Silver, steel, concrete, and pebbles
26 (L) x 2 ¼ (W) x ½ (D) inches
Collection of the artist

Lifting Weights 2004
Silver, 14K white gold, lead weights, brass, glass eyes, ebony piano keys, bone, horn, cotton cord, and coins
20 (H) x 10 ½ (W) x ¾ (D) inches
Collection of Susan Beech

Brigandine for Ishtar 2005
Copper, brass, nickel, steel, lead, and glass eyes
21 (H) x 16 (W) x 1 ½ (D) inches
Collection of the artist

Electric Fence 2007
Steel, copper, painted porcelain, and bone
16 ½ (H) x 14 (W) x 2 (D) inches
Collection of the artist

Literal Defense 2007
Aluminum, silver, brass, copper, glass eyes, vintage glass, 23K gold leaf, plastic, and leather
24 (H) x 13 (W) x 5 (D) inches
Collection of the artist

Note about measurements:
The formula for describing dimensions of a necklace that is commonly used by jewelers working with chains and pearl strands is length x width x depth. Length refers to the measurement of a necklace when it is opened at the clasp, laid out in a flat line, and measured end to end. Width refers to the widest component at any point along the length, and depth is the measurement of the relief, or how far the necklace protrudes from a form or person.

Some of Nancy Worden's neckpieces don't fit this formula. In those situations, length has been omitted and height has been used to indicate the measurement from the bottom of the piece to the top, especially in the cases with larger neckpieces that have a long extension in the back.

CHRONOLOGY AND INFLUENCES

Compiled by Rock Hushka and Nancy Worden

1954

Nancy Lee Worden was born on November 29, 1954, in Boston, Massachusetts. Her father was a graduate student then attending Boston University. Her paternal grandparents lived in Rockport, an artist colony north of Boston on Cape Ann. Her grandfather was a photographer and the president of the local art association. Worden's mother fostered her early artistic curiosity by taking her to many area museums, including the Museum of Fine Arts, Boston.

Worden's maternal grandparents were also important influences in her early artistic development. She credits the time she spent playing on their Quilcene, Washington, farm with developing her imagination and her ability to build things. Most importantly, she learned about her rich family history:

"I grew up in a family of story-tellers. My maternal grandfather was especially skilled at telling stories and jokes, and I was very fortunate to have spent a lot of time with him as a child. He was a farmer and a meat cutter, and I would hang out in the cutting house and listen to his stories. Grandpa Clark and his brother, Wayne, were raised by two eccentric aunts, Aunt Laura and Aunt Caroline, who had come to Idaho as pioneers and were the source of many hilarious tales. Grandpa had lived through the Great De-

At the farm near Quilcene, early 1960s

pression and two world wars. I learned a lot about American history as well as our family history from him. My mother, a college professor, inherited his storytelling skill, was a gifted mimic, and she read to us until we were old enough to read to ourselves. We did not own a television until I was a senior in high school: Mom broke down and allowed a TV in the house so we could watch the Watergate trials. Books and politics were a big part of our lives. It is no accident that I became a narrative artist and that my work often addresses current politics." (artist's statement, 2004–05)

Late 1950s

Worden remembers seeing her first handmade jewelry, a brooch in the shape of a crab made of silver and agate by an artisan in Rockport. For Worden, this brooch holds a special place in her memory.

Radically different from the other costume jewelry worn by her mother, this brooch represented the skill of the artist and conveyed a distinct connection to Cape Ann.

1961

Worden's father took a job at Yakima Valley Community College in Washington, in part because her mother wanted to be closer to her family. Worden's political outlook was shaped by her family's friendships with artists and other college professors, and her family was active in the Unitarian Fellowship. She remembers this time as one of liberal activism in a very conservative era and place.

1966

Worden's family relocated to Ellensburg, where her mother joined the faculty at Central Washington State College and eventually completed her Ph.D. from the University of Idaho. Continuing to remain active in local politics and community organizations, her mother served as county chair for the 1972 George McGovern campaign and volunteered her daughter to assist with her political efforts.

Princess of the 9th Grade Frolic, spring 1970

1970

Worden studied art with Kay Crimp at Ellensburg High School. For three years, Crimp guided Worden through these early art classes. As a junior, Worden took her first jewelry class with Crimp, during which time she made "modernist" jewelry.

Senior portrait, 1973

In her senior year, Worden concurrently enrolled in college-level classes at Central Washington State College. After reviewing the work she made in her high school art classes, Ken Cory allowed the precocious student into his classes with the understanding that she purchase her own tools.

1973

Worden entered Central Washington State College as a full-time student and began intensive studies with Cory, which continued until 1978. Cory introduced Worden to both fundamental jewelry construction techniques and jewelry history. Throughout these formative years, Cory also encouraged Worden to adapt ideas and traditions to suit her own artistic vision.

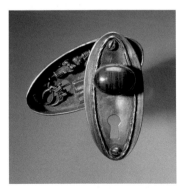

Door knob locket, 1972

1975

In the autumn, Worden worked as an intern for the alternative gallery *and/or* in Seattle, then directed by Anne Focke. Worden helped coordinate "Speaking of Art," public lectures by visiting artists, including William Wegman. This experience was Worden's first involvement with the Seattle arts community.

1977

Worden's first group show was the annual curated art exhibition associated with the Bellevue Arts and Crafts Fair, organized by the Bellevue Art Museum. Because she was still a student at Central Washington State College, this exhibition was an important signal of support for her growing talent and artistic vision.

Worden was also included in the *First National Ring Competition*, organized by the University of Georgia in Athens. Worden received the Jurors' Award for her submission. The university also acquired their first work by Worden.

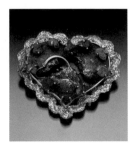

Heart-shaped brooch, 1977

1980

Worden began her graduate studies at the University of Georgia. She selected the university in part because of scholarship support but also because of the opportunity to learn advanced metal techniques from Gary Noffke. Noffke

Graduate student at University of Georgia, 1980

emphasized that an artist could develop an expressive vocabulary from a mastery of technique, process, and materials.

Worden was awarded an Honorable Mention in the *21st Sterling Silver Design Competition*, sponsored by American silver manufacturers such as Oneida and Reed & Barton. She submitted a hollowware cup crafted from her grandmother's antique silver spoons. The competition was juried by curator Lloyd Herman and artist Arline Fisch. This competition also brought Worden her first national exposure through the publicity packets assembled by Herman and Fisch and her first New York exhibition at Lever House.

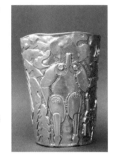

Spoon cup, 1979

1981

Worden returned to the Pacific Northwest and settled in Seattle. She began working at Tama, a jewelry retailer in Pike Place Market. She credits this job and other work in the jewelry manufacturing industry with introducing her to the business side of art and allowing her to meet distributors of gold and gemstones.

Worden also re-engaged with the Seattle arts community. One important experience was her participation in the conception and realization of the Bizart Store, which allowed artists to sell their products in various locations around the city during the holiday

season. Bizart is often considered crucial in developing a thriving art scene in Seattle during the early 1980s.

1984

Worden's first one-person exhibition, *Eight Brooches*, was presented by Polly's Wearable Art in Seattle.

1986

Worden had her first museum exhibition at the Bellevue Art Museum. Curator LaMar Harrington included three works, *Shattered Sight* (1984), *Mexican Citrine* (1984), and *Eyelet Lace* (1984; plate 2, page 67), in the group exhibition *Artwork/Working Art*.

Worden began working at MIA Gallery in Seattle, an art gallery with an emphasis on folk and naïve art. In 1987, Worden organized the first jewelry show at MIA Gallery, *Jewelry as Art*.

1988

Worden's *Venetian Vacation* (1986; plate 3, page 67) was included in Tacoma Art Museum's *Northwest Crafts '88*.

1990

Worden began a five-year association with the Northwest Folklife Festival. She organized ethnographic exhibitions for the festival, including the costumes and jewelry of Polynesia, Asia, and the ethnic groups of the Balkan Peninsula. This experience served as a crash course in history, geography, anthropology, and sociology and helped redirect her to incorporate her own experience and worldview more deeply into her jewelry.

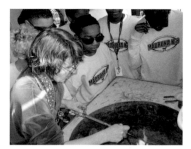
Casting at Pratt Fine Arts Center with Madrona 6th grade students

Worden began her involvement with Pratt Fine Arts Center in Seattle and revived the casting program. She was one of a number of artists, teachers, and patrons who helped grow and develop Pratt into a leading institution for professionals seeking to learn advanced skills.

1992

Worden's work was selected for *Art To Wear*, a juried exhibition at Larson Gallery at Yakima Valley Community College. Worden won the Dunbar Jewelers Creative Design in Jewelry Award.

Worden shifted the emphasis in her work to focus on the crucial subjects of home life and her personal narrative. She also sought to increase the dimensional qualities of her jewelry.

Recipient of Artist Trust GAP Grant, 1992

1993

Lloyd Herman included work by Worden in the exhibition and catalogue *Screams with Laughter: Storytelling in Northwest Craft* for the Bumbershoot Arts Festival in Seattle.

1994

Critic Matthew Kangas reviewed Worden's solo exhibition *Current Work* at Seattle's William Traver Gallery for the winter issue of *Metalsmith* (vol. 14, no. 1). Kangas concluded his review by likening Worden's narrative jewelry to the great tradition of southern storytelling, comparing her to writers Peter Taylor and Eudora Welty.

Age 40, wearing Seven Deadly Sins

1995

Kangas included Worden's *The Seven Deadly Sins* (1994; plate 13, page 73) in his article "Ellensburg Funky" for the winter issue of *Metalsmith* (vol. 15, no. 4). Kangas elaborated on the influence of artists such as Cory and Noffke on Worden's style and technical skills but noted that she never sacrificed her personal vision. She is quoted: "My work looks like an American woman designed it and I want it to."

As a featured speaker, Worden presented a lecture on the work of Ken Cory at the North American Goldsmiths Conference in New Orleans, Louisiana. In conjunction with her presentation, she organized *Ken Cory: The Best of Thirty Years*, a mini-retrospective, for the LeMieux Galleries.

The American Craft Museum in New York (now the Museum of Arts & Design) acquired *The Seven Deadly Sins*. Two years later, the museum included this work in their exhibition *Jewelry from the Permanent Collection*.

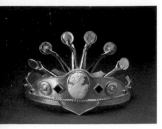

Charity Tiara, 1995

Worden received a commission from the City of Seattle to create the series *The Importance of Good Manners*.

1996

The article "The Rematerialization of the Art Object" by Matthew Kangas appeared in the July/August issue of *Sculpture* (vol. 15, no. 6). Kangas included Worden's *Charity Tiara* (1995; plate 14, page 74) to illustrate his observation that Worden and many other artists employed craft-based techniques to match "their quest for profound personal expression."

Cover of Ornament *magazine, 1996*

Worden's *Terminology* (1996; plate 18, page 76) graced the cover of the autumn issue of *Ornament* (vol. 20, no. 1). Her work was the subject of the feature article "Nancy Worden: Passionate Statements" by Carolyn L. E. Benesh.

Curator Bruce Pepich included work by Worden in *Just Add Water: Artists and the Aqueous World* at the Racine Art Museum in Racine, Wisconsin.

1997

Worden and artist Les LePere co-curated the exhibition *The Jewelry of Ken Cory: Play Disguised* at Tacoma Art Museum, working closely with Chief Curator Barbara Johns. This exhibition and catalogue project connected Worden to Tacoma Art Museum and invigorated the growth of the museum's collection of studio art jewelry by Northwest artists.

1998

Helen Williams Drutt English published *Brooching It Diplomatically: A Tribute to Madeleine K. Albright* and organized a two-year, internationally traveling exhibition, which included work by Worden. Worden's *United States—Arms Agreement* (1998) was featured in the article "Brooching It Diplomatically: A Tribute to Madeleine K. Albright" in the 1999 February/March issue of *American Craft* (vol. 59, no. 1).

Worden's *Casting Pearls before Swine* (1997; plate 20, page 78) was featured on the cover of the October/November issue of *American Craft* (vol. 58, no. 5). The feature article by Susan Biskeborn, "Nancy Worden: Getting Personal," explored in depth Worden's personal narratives as re-created in her jewelry.

The Seattle Art Museum acquired *Dead or Alive* (1997; plate 19, page 77).

The Racine Art Museum acquired *Bathroom Bowl Blues* (1992; plate 5, page 68).

Helen Williams Drutt English and Worden began their long-term professional relationship, both as artist and gallery owner and artist and patron.

Cover of American Craft *magazine, 1998*

1999

Worden's work was included in numerous group exhibitions throughout the United States, including *BEADZ! New Work by Contemporary Artists* at the American Craft Museum.

This year marked the beginning of a series of regular one-person exhibitions for Worden at both William Traver Gallery in Seattle and Helen Drutt: Philadelphia.

Tacoma Art Museum acquired *Initiation Necklace* (1977; plate 1, page 66). In 2003, the museum acquired *Broken Trust* (1992; plate 6, page 69).

2000

On a side trip to London en route to the Association for Contemporary Jewellery International Conference in Birmingham, England, Worden visited the new Tate Modern to see *The Unilever Series: Louise Bourgeois: I Do, I Undo, I Redo*. At the exhibition, Worden realized how Bourgeois crafted her monumental installation to demand an experiential relationship with an artwork. Worden also marveled at Bourgeois' representation of self-exploration that allowed visitors to have similar epiphanies about their own sense of self. She came to the realization that jewelry could evoke the same experiential interaction between the wearer and the artist that Bourgeois created between her viewers and her installation. She was inspired to create jewelry that would demand physical effort and mental fortitude by the wearer. Her goal was to distill her artistic vision and intellectual work into jewelry that would not only convey her narrative but also empower the wearer to evolve to a higher level of self-awareness.

The Stedelijk Museum 's-Hertogen-bosch, Netherlands, acquired *I Feel Pretty* (1993; plate 8, page 70), *Mixed Messages* (1993; plate 9, page 71), and *Diamonds and Lust* (1998; plate 22, page 81).

2001

Robin Updike's article "Multigener-ational Themes: Nancy Worden" was featured in the spring issue of *Ornament* (vol. 24, no. 3). Updike emphasized the recent themes of "familial relationships and the uni-versal longing for a home that is a safe haven" in Worden's work.

2004

Worden received the Distinguished Alumni of the Year award from the College of Arts and Humanities at Central Washington University.

Helen Williams Drutt English in-cluded a selection of Worden's work in the exhibition *A View from America: Contemporary Jewelry (1974–2003)* at the Gold Treasury Museum in Melbourne, Australia.

2005

Worden's work was included in the group exhibitions *Transformation 5: Contemporary Works in Found Materials* at the Society for Con-temporary Craft, Pittsburgh, and *Magnificent Extravagance: Artists and Opulence* at the Racine Art Museum.

With Peter Olsen, Ramona Solberg, and Ron Ho, 2005

With Helen Williams Drutt English at the opening of Ornament as Art *at the Museum of Fine Arts, Houston, 2007*

Richard Speer wrote "Nancy Wor-den" for *Artnews* (vol. 104, no. 6), a review of her one-person exhibi-tion *Modern Artifacts* at William Traver Gallery in Seattle. The show was also reviewed in Suzanne Ramljak's article "Protective Ornament: Dressed for Defense" in *Metalsmith* (vol. 25, no. 2).

2006

The Hallie Ford Museum of Art at Willamette University in Salem, Oregon, included works by Worden in their exhibition *Recycled Art*.

Matthew Kangas wrote the feature article "Nancy Worden: Excava-tions" for the spring issue of *Met-alsmith* (vol. 26, no. 1). Unlike his 1994 review in which he identified the narrative thread of her work, this article examined Worden's efforts at psychological excava-tions and her use of materials that provided important symbolism for women of Worden's and her mother's generations.

The Museum of Fine Arts, Boston, acquired the Daphne Farago Collection, including Worden's *Runnin' Yo Mama Ragged* (1992;

plate 7, page 70) and *Terminology* (1996; plate 18, page 76).

2007

Worden's *Conventional Weapons* (1997) and *Buying Time* (1999; fig. 2, page 10) were included in the acquisition of the Helen Williams Drutt Collection by the Museum of Fine Arts, Houston. The collection was featured in an important catalogue and began a national tour that included the Museum of Fine Arts, Houston; the Renwick Gallery of the Smithson-ian American Art Museum, Wash-ington, DC; the Mint Museum of Craft + Design, Charlotte, North Carolina; and Tacoma Art Museum.

2008

Traver Gallery in Tacoma presented *Fear Factor,* a one-person exhibi-tion of new work that continued Worden's exploration of tools as metaphors and symbols for psy-chological excavation. This exhibi-tion was her tenth one-person gallery show and marked an impor-tant milestone in her career.

2009

Tacoma Art Museum organized *Loud Bones: The Jewelry of Nancy Worden,* the first scholarly survey of her career. The exhibition will be shown at the Hallie Ford Museum of Art at Willamette University in the autumn.

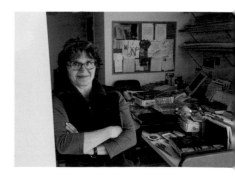

In the studio, 2008

ARTIST AND CURATOR ACKNOWLEDGEMENTS

WHEN I MADE THE CAREER CHOICE to be an artist, I knew it would be a risky business. Fortunately, I have been able to germinate and grow to maturity in a community that loves and nurtures the arts and solidly supports a museum that is committed to the artists of the Pacific Northwest, Tacoma Art Museum. Throughout my long association with the museum and the staff there, past and present, I have always found a listening ear to my ideas and proposals. After tossing out one unorthodox idea to former director Janeanne Upp, she responded, "I don't have any idea what you're talking about, but I trust that you can pull it off." Trust is one of the essential nutrients for creativity, and to Margaret Bullock, Rebecca Jaynes, Stephanie Stebich, and especially Rock Hushka, I want to say thank you for your trust, caring, and conscientious work and for listening to me, even when it was hard. I am so proud to have worked with you.

I continue to be amazed at the generosity and support of the many collectors and museums that have contributed to this exhibition and catalogue—thank you for helping me to realize the dream of this project. I am particularly grateful to my collectors that really belong in the patron category: Susan Beech, Helen Williams Drutt English, Lois Boardman, Daphne Farago, and Marion Fulk. These strong women not only buy my work, they wear it in public! Thank you for continuing to invest in me.

A fountain of gratitude to the many cheerleaders who have promoted my work and made me look good every day: my photographers, Rex Rystedt, Doug Yaple, Lynn H. Thompson, Joel Levin, and Robert Liu; my gallerists, William and Sarah Traver, Helen Williams Drutt English, Libby Cooper, and Mia McEldowney; and my friends in the media, Matthew Kangas, Lois Moran, Susan Biskeborn, Robin Updike, Judy Wagonfeld, Suzanne Ramljak, Carolyn Benesh, Robert Liu, and the entire staff of *Ornament*. A long round of applause and an apple pie for Phil Kovacevich, the book designer on this project, and his unlimited patience. Special thanks to Dr. Susan Noyes Platt, Professor Michelle LeBaron, and visionary Helen Williams Drutt English, the writers that contributed to this catalogue. Your words humble me.

Last, but not least, an ocean of gratitude to my friends and family who have helped to steer me through the uncharted waters of an artist's career: Sherry Markovitz, Peter Millett, Lori Talcott, Greg Bell, Robert Kaplan, Jane Orleman, the late Dick Elliott, my assistant Monica Giudici, and especially my husband and daughter, Will and Avery Reed. As Dick so aptly put it, "If you don't believe in your art, no one else will." Thank you all for encouraging me to believe in myself.

NANCY WORDEN

A PROJECT OF THE SCOPE of *Loud Bones* comes together successfully only from the shared vision and passion of many people. First among these is Nancy Worden. For almost a decade, Nancy has been an important part of my work at Tacoma Art Museum. She has been unfailingly generous with her time, expertise, and opinions. We are indebted to her for her patience and guidance on all aspects of *Loud Bones*. In a larger context, Nancy has provided me with a rigorous knowledge of Northwest jewelry and its historical context. Without her input, our museum's efforts to exhibit and collect studio art jewelry would have fallen far short of our goals.

I thank essayists Dr. Susan Noyes Platt and Professor Michelle LeBaron for their contributions to this catalogue. Both scholars worked closely with Nancy and the museum to craft important new essays. It is important to acknowledge that they labored outside their usual areas of expertise and mastered new topics and material in service to this project.

For their work on the exhibition and catalogue, special acknowledgement rightly must be given to my colleagues in the curatorial department. Zoe Donnell worked diligently to track details of the exhibition and served as proofreader. Michelle Kinney carefully managed the myriad of art loans. James Porter helped raise our exhibition standards for jewelry, one of the most difficult objects to display in a museum context. Rebecca Jaynes managed the production of the catalogue with aplomb. Margaret Bullock played a critical role in developing the exhibition.

Because *Loud Bones* marks an important milestone in the history of the museum, I would like to thank two museum patrons who have made this possible. In 2003, Tacoma Art Museum revived its collecting emphasis on studio art jewelry. Sharon Campbell worked tirelessly to help us build the collection. Through her carefully coordinated efforts and advocacy, our museum emerged as a leader in this field. At this time, Sharon introduced Susan Beech to Tacoma Art Museum, and she joined our group of museum patrons in support of our studio art jewelry collection. Since this auspicious beginning, we have been fortunate to continue this relationship. We are deeply indebted to Susan's early and ongoing generosity with *Loud Bones*. Because her passion and advocacy for studio art jewelry reaches across the nation, we are grateful that Susan includes our museum as part of her vision for the growth of this field.

ROCK HUSHKA

TACOMA ART MUSEUM STAFF

Stephanie A. Stebich, Director

Allison Baer, Education Assistant

Derrek Bull, Security Officer

Margaret Bullock, Curator of Collections and Special Exhibitions

Kathy Cabusao, Private Events Manager

Christina Cao, Store Inventory and E-commerce Specialist

Craig Colberg, Security Officer

Irene Conley, Security Officer

Carolyn Crannell, Store Inventory Assistant

Kelly Crithfield, Assistant to the Director and Administrative Coordinator

Frank Culhane, Manager of Facilities and Security

Matt Daugherty, IT Systems Administrator

Denise De Busk, Visitor Services Representative

Liz Donaldson, Development Assistant

Zoe Donnell, Curatorial Coordinator

Thomas Duke, Membership Coordinator

Tobin Eckholt, Development Services Coordinator

Cameron Fellows, Deputy Director and Director of Finance and Administration

Lindsey Frallic, Manager of Corporate and Foundation Relations

Marty Gengenbach, Visitor Services Manager

Allison Hill, Visitor Services Event Lead

Kara Hefley, Director of Development

Rock Hushka, Director of Curatorial Administration and Curator of Contemporary and Northwest Art

Ellen Ito, Visitor Services Lead and Curatorial Liaison

Rebecca Jaynes, Editorial Coordinator

Melisa Jennings, Museum Educator and Community Programs Coordinator

Megan Jones, Visitor Services Representative

Phoebe Keleman, Marketing Assistant

Michelle Kinney, Registrar

Boun Lameny, Security Officer

Paula McArdle, Director of Education and Audience Development

Brian McCarthy, Visitor Services Representative

Angie Mingus, Food Service Manager

Morgan Moulongo, Manager of Individual Major Giving

Robbi Nanakul, Store Sales Associate

Moira Neet, Visitor Services Representative

Jennifer Peters, Visitor Services Representative

James Porter, Senior Preparator

Julie Rivera, Visitor Services Lead

Jonathan Smith, Finance Manager

Allison South, Exhibition and Collection Assistant

Scott Sumara, Security Officer

Pei Pei Sung, Graphic Designer

Courtney Vowels, Manager of School and Teacher Programs

Jana Wennstrom, Volunteer Programs Coordinator

Kristie Worthey, Associate Director of Museum Services

LENDERS TO THE EXHIBITION

Susan Beech

The Boardman Family

Jacqueline Fowler

Marion Fulk

Lynn and Jeffrey Leff

Mia McEldowney

Museum of Arts & Design,
 New York

Museum of Fine Arts, Boston

Laura Oskowitz

Racine Art Museum

Seattle Art Museum

Seattle City Light 1% for Art
 Portable Works Collection

SM's - Stedelijk Museum
 's-Hertogenbosch / NL

Tacoma Art Museum

Judith A. Whetzel

Nancy Worden

Susan Beech wearing Hidden Agenda,
and Zipper Bracelet *from* Shackles of
Fear, *2007*